WARWICK
THROUGH TIME
Jacqueline Cameron

AMBERLEY PUBLISHING

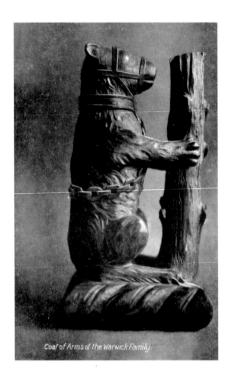

Bear and the ragged staff.

To Jean and Denis, here's to a beautiful friendship.

The old images on pages 28, 35, 37, 38, 41 and 51 are reproduced by kind permission of the Warwickshire Library and Information Service.

First published 2009

Amberley Publishing Plc
Cirencester Road, Chalford,
Stroud, Gloucestershire, GL6 8PE

www.amberley-books.com

Copyright © Jacqueline Cameron, 2009

The right of Jacqueline Cameron to be identified as the Author of this work has been asserted in accordance with the Copyrights, Designs and Patents Act 1988.

ISBN 978 1 84868 874 2

British Library Cataloguing in Publication Data. A catalogue record for this book is available from the British Library.

Typeset in 9.5pt on 12pt Celeste.
Typesetting by Amberley Publishing.
Printed in the UK.

Introduction

What greater pleasure could there be than to be asked to write a Through Time book about the town you were born in? Such an honour was bestowed upon me by Alan Sutton, and I cannot express too much my gratitude to him for such a golden opportunity.

Warwick has changed so much from the days of my childhood, where you went to school to be told your best friend's Daddy had died on 'the Front' the day before. I sat and looked at the empty desk all day wondering what 'the Front' was. I also vividly remember playing up Old Park Lane and seeing the body of an airman hanging in the tree with his parachute strung up in the branches above him. These were Second World War years and despite this, childhood was a happy time, where we played in the crater a German bomb had left behind on the common in the Cape where I grew up, and thought nothing of it as we made lovely dens! We huddled under the stairs when the siren went off and I was very proud of my orange gas mask as my sister only had a black rubber bag with a glass front to look out, where Mother placed her in times of trouble. Waiting in the coke queue at the gas works in Birmingham Road was another adventure, as Father would push an old broken down pram to carry it in. As I grew up we would walk the mile or so to school and back, as there were no buses and certainly no Mothers driving us to and from school. In fact many Mothers did not drive at all. A car was a luxury that no one took for granted. I cannot mention school without mentioning the small bottles of milk, the dentist visit, the lady who came to check for fleas, and the afternoon rest period, where you placed your head on your arms on the desktop, in a darkened room and were supposed to sleep. I have never known time to pass so slowly! On Monday morning Mr Wilson would dish out the punishment for being naughty and there was usually a column of young lads standing with outstretched hands waiting for a rap with the ruler. I don't think it worked because the Monday queue never got any shorter. One morning while going to school a red double-decker bus drove into the market square and we all stood in wonder, staring at it. We had seen pictures of red double-decker buses but never the real thing. I still remember with affection the day Mother gave me my first banana and I didn't know what to do with it. Bananas were scarce when there was a war on.

Much has also been written about Warwick and its castle over the years as. The castle is one of the finest in England and dates back to 1068, just two years after the Norman Conquest.

As you enter Warwick you cannot help but notice the East and West Gates which marked part of the medieval defences of the town. Both gates still have a short length of genuine town wall attached to them. Above the East Gate can be found St. Peter's Chapel which started life as a small parish church near the centre of the town. It was rebuilt over the East Gate in the fifteenth century. Over the West

Gate is the chapel of St. James. To this day you can still walk through the gates on cobbles which are probably as old as the gates themselves. Unfortunately due to the age of the arches the West Gate is currently being repaired and is surrounded by netting and scaffolding but you are still able to walk through the arch.

Warwick is steeped in history and no introduction to the town would be complete without mentioning the Lord Leycester Hospital and the Malt House, which is the Elizabethan building leading to the gate of the great house. There is the market hall and museum which was erected for the borough by a local builder William Hurlbutt in 1670, and the Abbotsford which stands at the north end of the market place and was built in 1714 to replace the Bull Inn.

The original Warwick prison stood in Northgate Street and was found to be serious danger to the health of the prisoners and wardens alike and was abandoned in 1860 for a newly built prison at the Cape. Warwick Priory, which no longer stands in Priory Park, was much altered and greatly extended during its lifetime in England, before being shipped to Richmond, Virginia, in America. The Priory had been put up for sale in 1925, which resulted in it being purchased by Mr and Mrs Alexander Willbourne-Weddell, the former American Ambassador to Spain.

Guy's Cliffe House, which stands on a steep slope overlooking the River Avon is also worthy of mention. Very much a ruin, this once magnificent house was reputed to have been the place where the legendary Guy of Warwick retired as a hermit. One of my most treasured memories of Warwick is its famous yearly Mop Fair, which is the only traditional fair to survive to the present time. The first fair in Warwick was held in 1261, when John du Plesses was given permission to hold a fair for eight days around the feast of St. Peter. I well remember the reintroduction of the hog roast after the Second World War, and the queue I stood in while Mother purchased a pork roll so that we could taste what it used to be like.

Warwick has many claims to fame and one I like is the fact that Henry Ford's wife's family came from Warwick. The Fords would come to the town to visit the 'in laws' who lived in Theatre Street and while Clara caught up with all the family news, Henry would walk around Warwick and on occasions tried to recruit employees for his car company in the States.

It has been lovely travelling through time in Warwick and to revive the memories of how the town has changed over the years. Characters of the town are still regarded with affection; Ben Cowley, the butcher, Chris Jones and his vegetable shop in the market square and Fred Vittle the undertaker, who always seemed to have a sour look on his face. Then there was Dr Mulligan the GP, Mr Cohen the dentist and the two coal merchants who delivered coal around the houses Messrs Hunt and Dillow. No journey down memory lane would be complete without mentioning Mabel Buswell and her dad, who through sunshine, rain and snow, managed to delivered fresh vegetables from her horse and cart to her customers' front doors.

You either love or hate the changes made to the town over the years but it does nothing to compare with the people who make Warwick a most interesting and delightful town to live in.

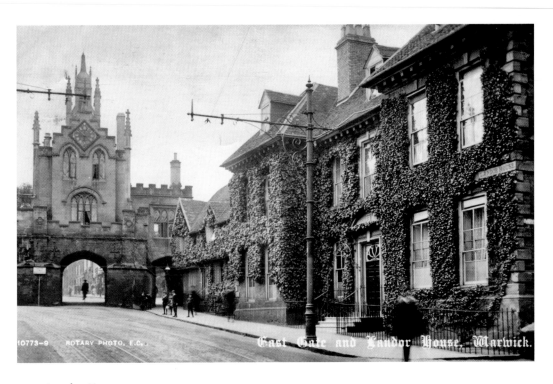

Landor House
Formerly the home of the poet Walter Savage Landor, it is now part of the Kings High School for Girls. Roger Hurlbutt designed the seventeenth-century building.

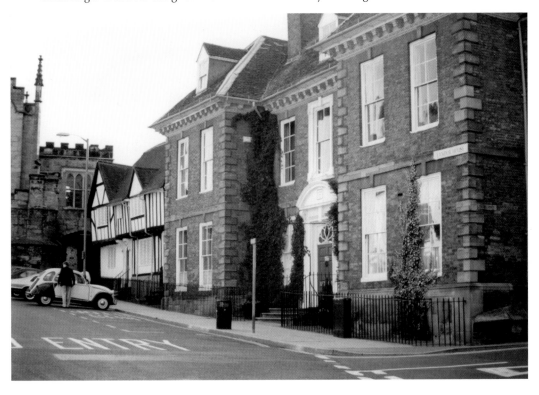

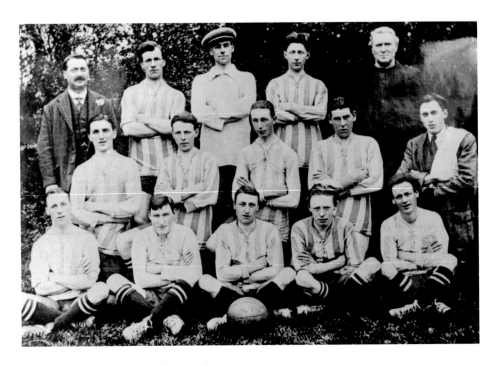

Warwick and Hampton Hill Football Teams

Above: Hampton on the Hill football team, taken in 1921/2. Only the names of the players in the front row are known. From left to right they are: E. Tracy, T. Collett, G. Bourton, B. Vincent and T. Field.

Below: Warwick football team, taken in the 1950s.

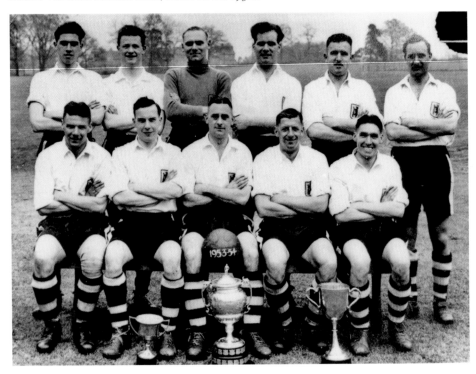

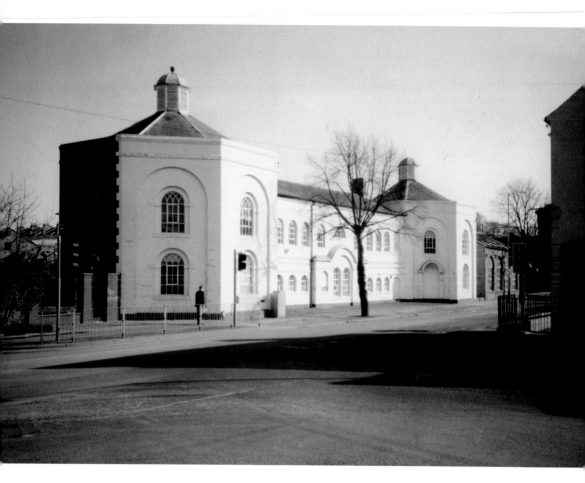

Warwick Gasworks

Warwick gasworks are no more, but the building in the photograph still stands and is currently undergoing modernisation. The place has had a lick of paint, and the cupolas can still be seen looking as grand as ever.

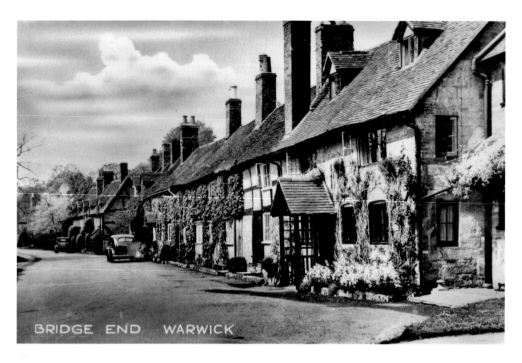

BRIDGE END WARWICK

Bridge End and The New Bridge

Bridge End is an area across the river from the castle, which looms romantically in the background of this photograph taken in the 1950s. Many of these old houses look very much the same as they always have done and have changed very little over the years.

Twenty-five feet high and thrity-six feet wide, the 'new' bridge into Warwick consists of one span-arch, which was built in 1790. The architect was William Eborall.

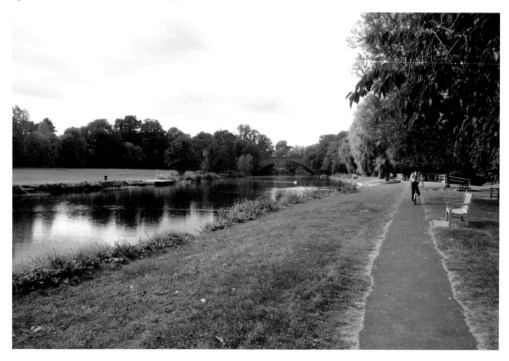

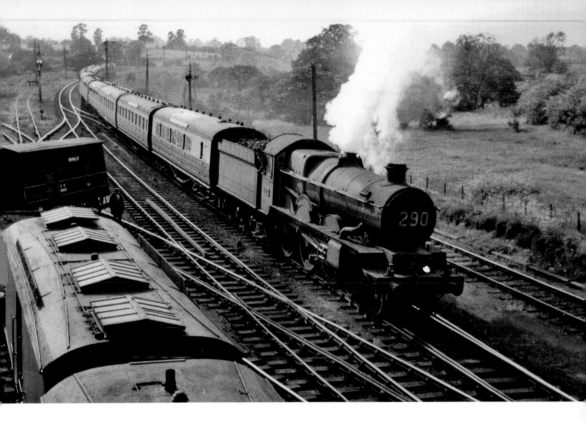

En Route

This delightful photograph of a steam train, the 5027 Farleigh Castle, was taken outside Hatton Station where it was *en route* to Warwick in 1931. The bottom picture shows just how much train travel has altered over the years.

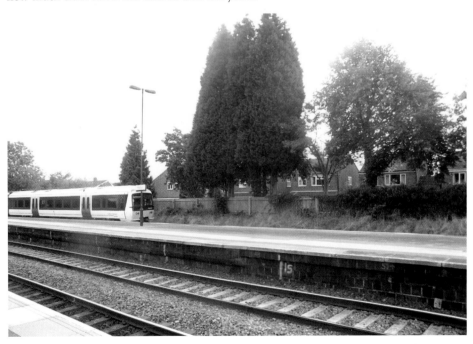

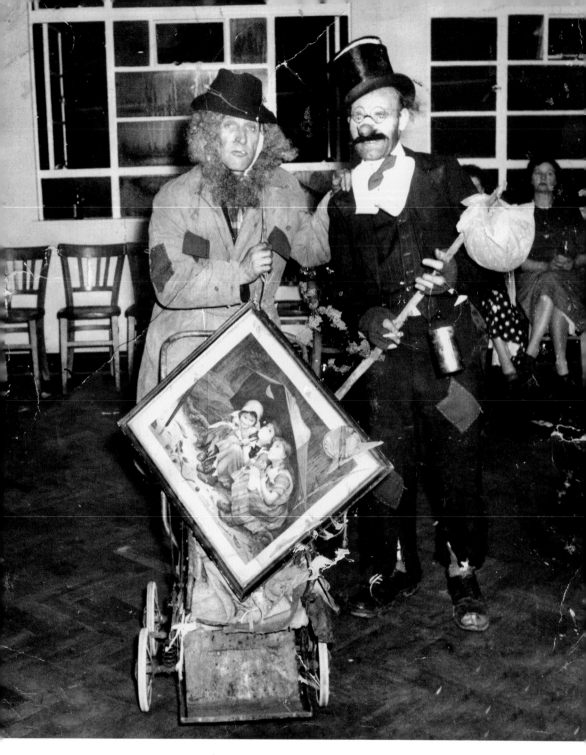

Tramps' Ball
Here we see Johnny Haynes and friend Albert who won first and second prize at the John Harris Tramps' Ball, 27 January 1957. For many years, John Harris conducted his business in Wathen Road, Warwick. The business has now gone but the memories linger on.

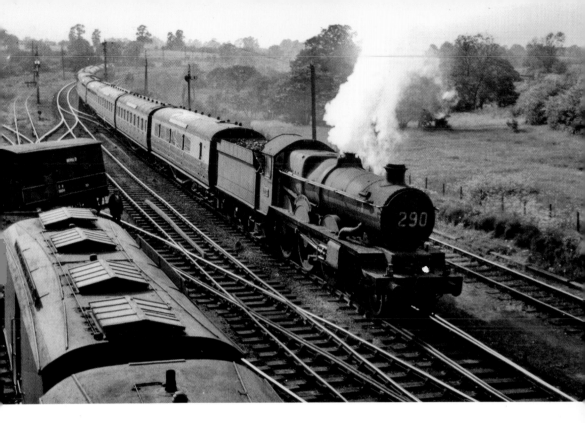

En Route

This delightful photograph of a steam train, the 5027 Farleigh Castle, was taken outside Hatton Station where it was *en route* to Warwick in 1931. The bottom picture shows just how much train travel has altered over the years.

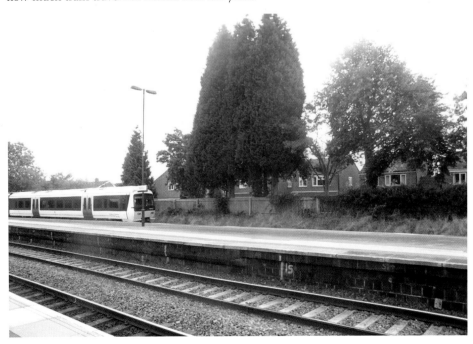

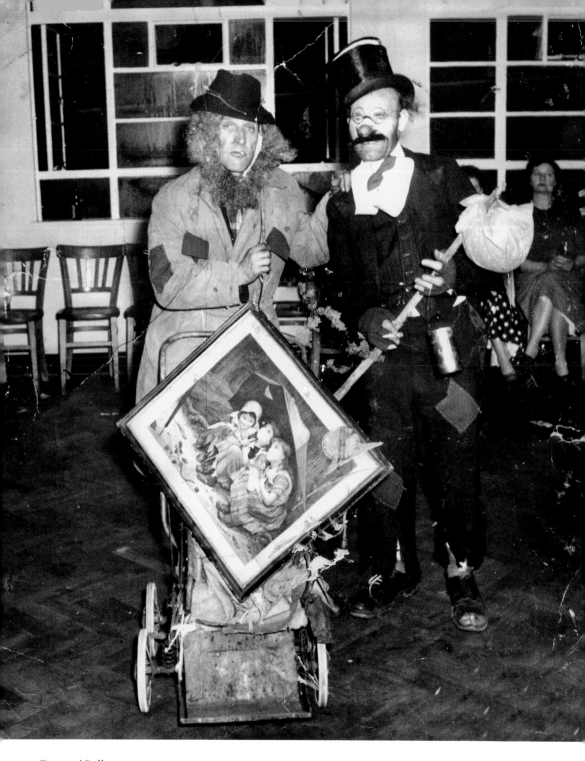

Tramps' Ball
Here we see Johnny Haynes and friend Albert who won first and second prize at the John Harris Tramps' Ball, 27 January 1957. For many years, John Harris conducted his business in Wathen Road, Warwick. The business has now gone but the memories linger on.

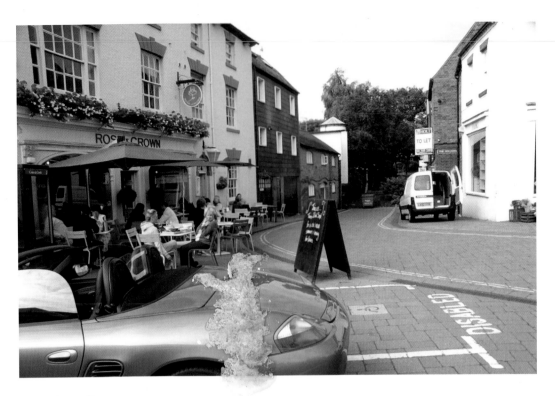

The Holloway

A view of the Holloway from outside the Rose and Crown public house. The white building in the centre of the photograph is the old police station in Barrack Street, which is now the site of the public library.

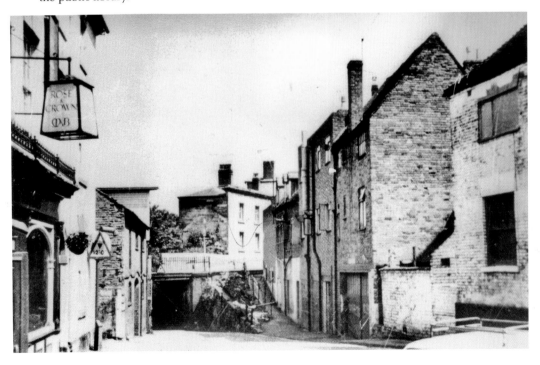

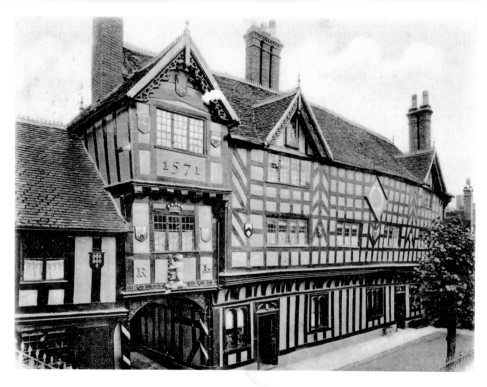

Lord Leycester Hospital

In the mid-1600s, ancient almshouses were frequently requisitioned for military use and Lord Leycester's was no exception. The hospital's life was disrupted and its revenue disappeared when parliamentary troops took over the chapel and constructed the town's fortification through its grounds. This was long ago and, although the house looks very much as it always has done, it has now become a popular tourist attraction.

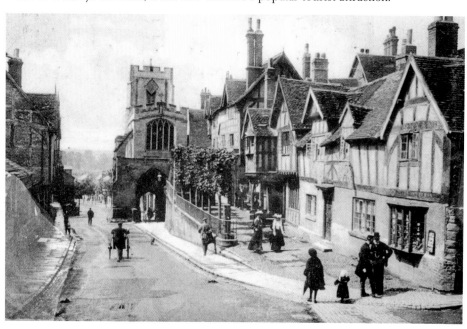

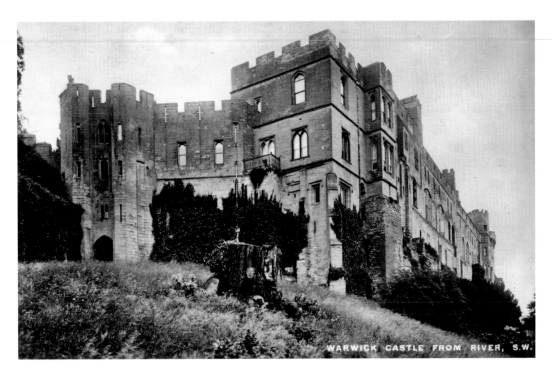

WARWICK CASTLE FROM RIVER, S.W.

Warwick Castle

The east front of the castle was painted by Canaletto for £29 for Francis Greville, Baron Brooke. In 1977, Birmingham City Museum and Art Gallery purchased it for £275. Canaletto remained in England for ten years but died in Venice on 19 April 1768. Baron Brooke, who became Earl of Warwick in 1759, died on 6 July 1773.

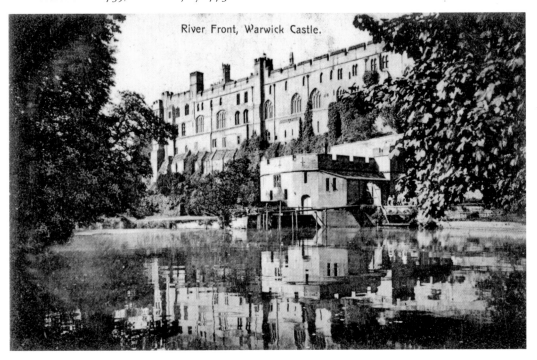

River Front, Warwick Castle.

From the Deep
While I was out taking the photographs for the book at the Saxon Mill, this gentleman appeared from under the water, where, unbeknown to me, he had been diving. It gave me quite a turn!

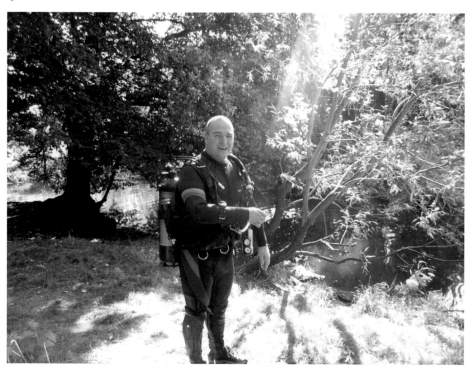

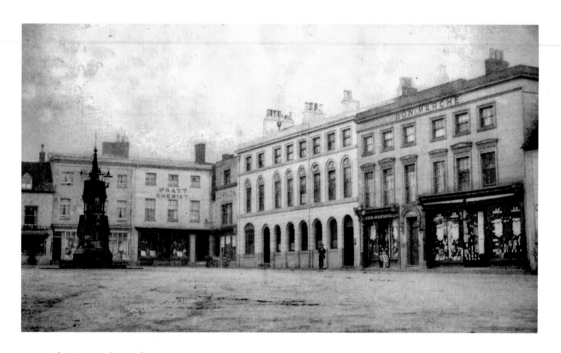

The Fountain and J. Hatton & Company

Standing in the middle of the square, the fountain was built to commemorate Queen Victoria and Prince Albert's visit to Warwick in June 1858.

J. Hatton & Company's Bon Marche opened for business in 1898 and their flourishing drapery business was to continue until the premises closed in the 1950s. I well remember visiting Hatton's on an errand for my mother as a child, and my memories of the shop are ones of nostalgia for a lovely bygone era.

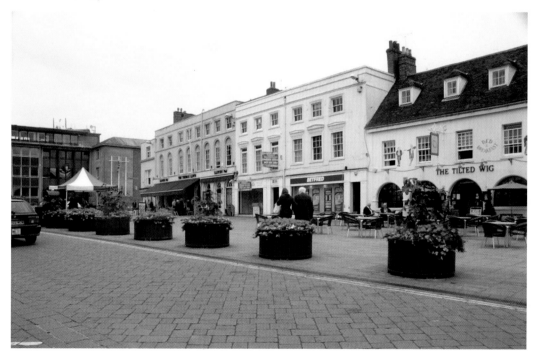

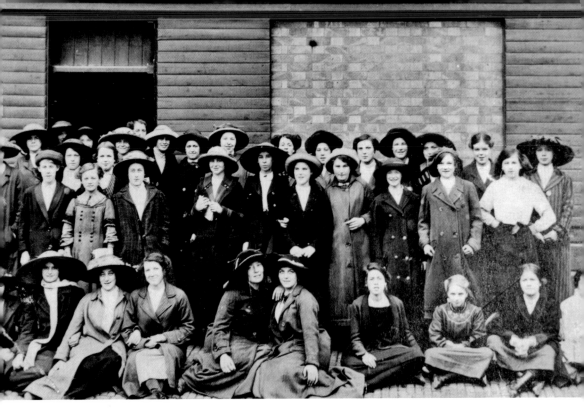

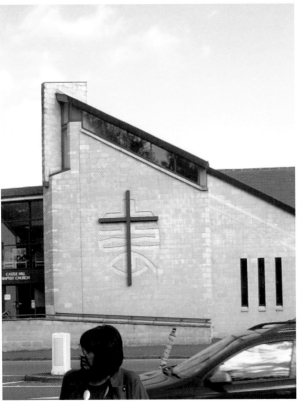

Warwick Cigar Factory
This picture was taken around 1914, outside the Warwick cigar factory on Castle Hill. During the First World War, the girls would look for news from the Front from a noticeboard fixed on the castle wall opposite, where the reports were posted. Today, we have the recently-rebuilt Baptist church on the site.

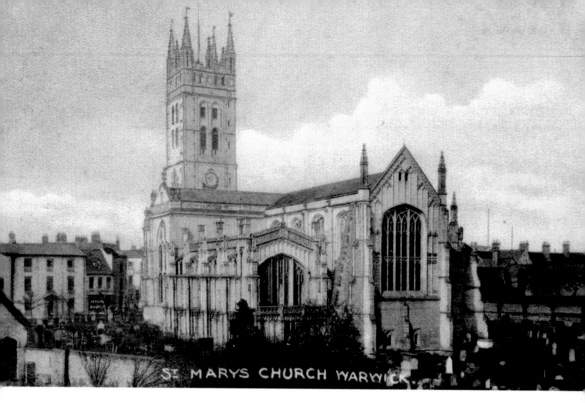

St MARYS CHURCH WARWICK.

St Mary's Church

St Mary's church was established in 1123 as a collegiate church by Roger Newburgh, Earl of Warwick. In the middle of the fourteenth century, Thomas Beauchamp, who himself was to become Earl of Warwick, planned a larger church, but he only survived long enough to extend the crypt and died in 1369. He was buried beneath the fine alabaster monument before the high altar in the chapel above.

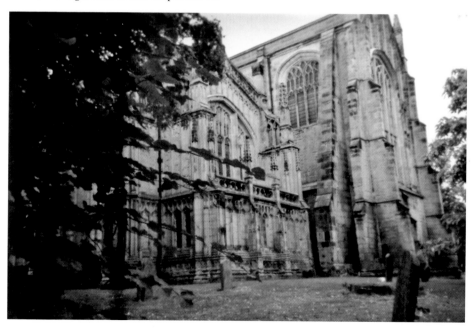

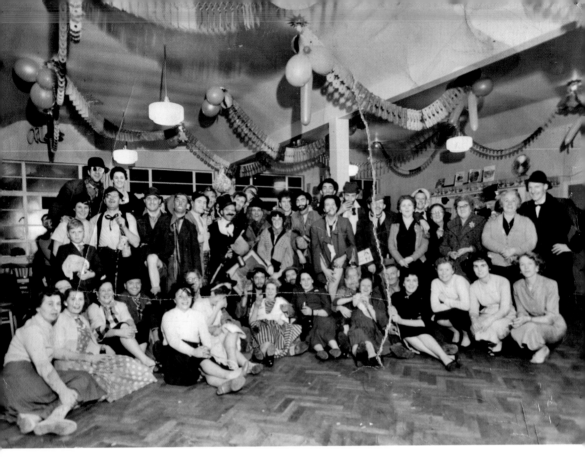

John Harris Tools

The fun continues at John Harris's Tramps' Ball on 27 January 1957, and here we have a group photograph of all the employees who were lucky enough to be invited.

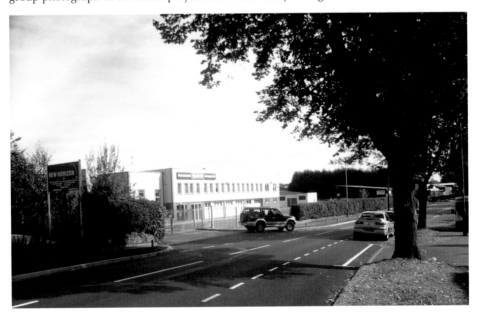

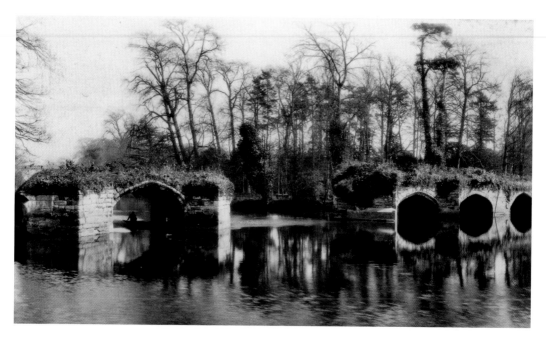

The Old Bridge

Now in ruins, the old bridge formerly connected Bridge End to Mill Street, at the castle end. Although it is now in ruins, the remains of the bridge are visible from the end of Mill Street and make a pretty picture, with the ivy on the brickwork and the swans on the river Avon.

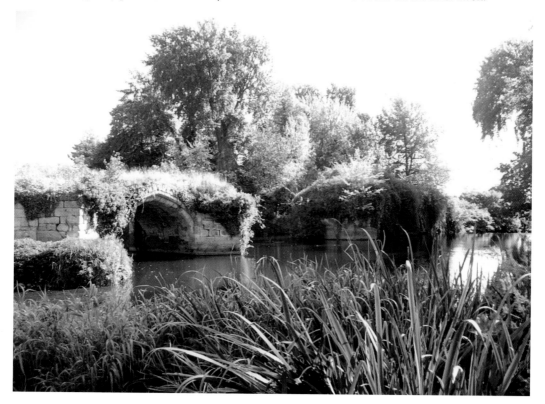

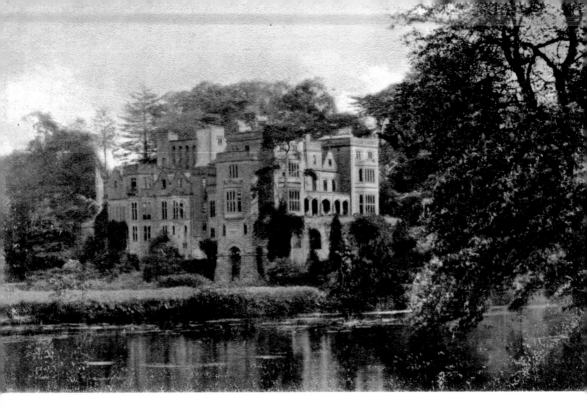

Guy's Cliffe House
Built for Mr Greatheed in 1751, the house was later converted by Mr Bertie Greatheed early in the nineteenth century. Acting as architect, Bertie Greatheed left the house lacking some of the glory of the original Georgian building. The house was built on the site where the legendary Guy of Warwick lived as a hermit in the tenth century.

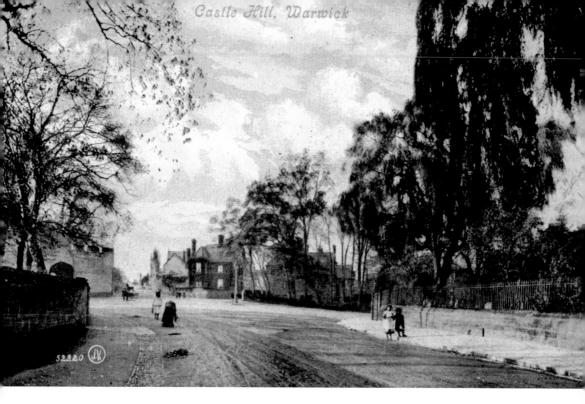

52220

St Nicholas' Church

Standing behind the trees on the right of this photograph is St Nicholas' Church, which dates back to Saxon times and was rebuilt in 1779. Consisting of a nave with a tower and spire at the west end, the chancel was added in 1869. The church has an interesting brass plaque within its walls in memory of Robert Willardsey, the first vicar in 1424.

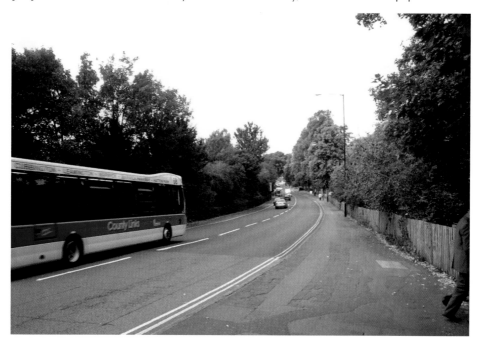

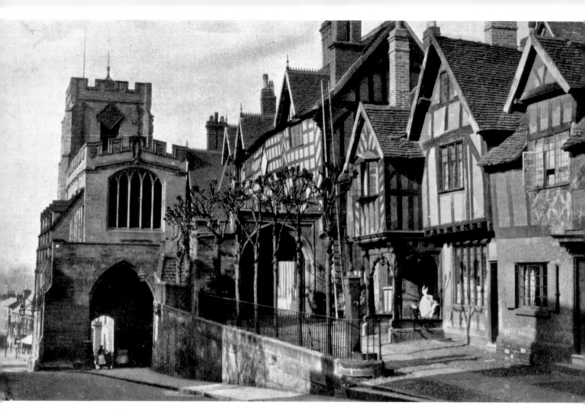

West and East Gates
The West and East Gates, which are the only two original surviving gates into Warwick.

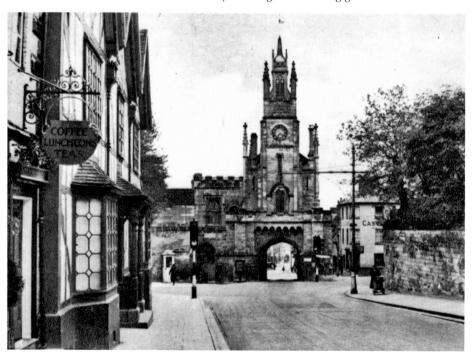

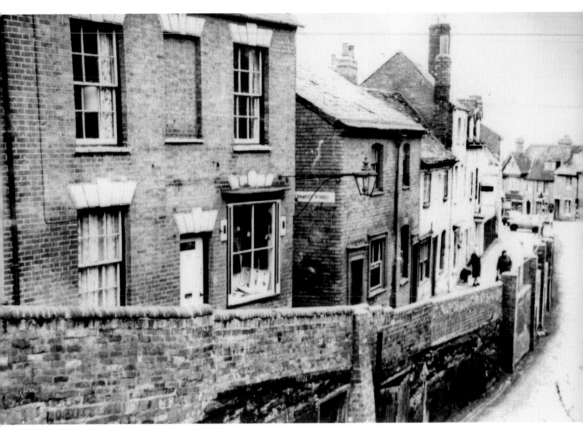

The Rock
Constructed from the underlying rock surface is another view of the Holloway, which brings back happy memories of my childhood, as we passed along here each day on our way to school. Traffic would travel along the road below into the centre of the town.

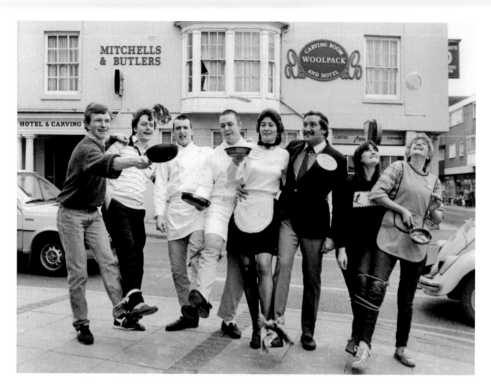

Pancake Day

Staff from the hotels around Warwick town centre took part in a three-legged race in the town's market square to celebrate Pancake Day. The racers are, from left to right, Neil Chapman and Graham Eyles and Guy Dixon and Mark Burney from the Woolpack Hotel, Jean Tichelly and John Haywood from the Warwick Arms, and the winners Mandy Algar and Kay Burcham, also from the Woolpack. Although the Warwick Arms is still in business, the same thing cannot be said about the Woolpack, which has now been converted into a housing complex.

Beauchamp Chapel

Built in accordance with the will of Richard Beauchamp, Earl of Warwick, who died in 1439, the Beauchamp chapel is in the south side of the choir. The central monument is a superb piece of workmanship. The tomb chest is of Purbeck marble enriched with fourteen golden-bronze 'weepers'. The enamelled coats of arms are those of Richard Beauchamp's son and other relatives.

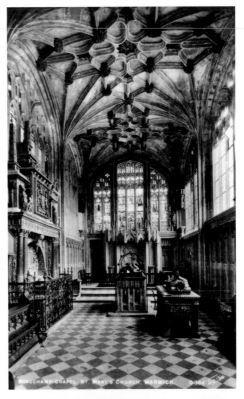

BEAUCHAMP CHAPEL, ST MARY'S CHURCH, WARWICK.

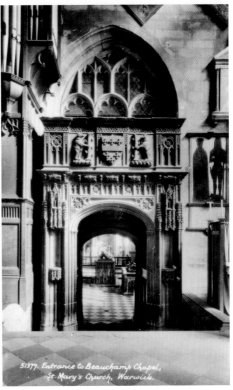

51377. Entrance to Beauchamp Chapel, St. Mary's Church, Warwick.

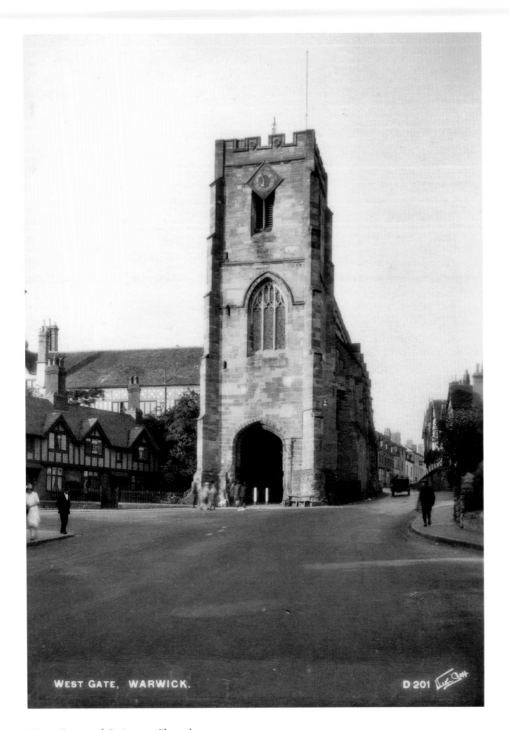

WEST GATE, WARWICK. D 201

West Gate and St James Chapel

Standing on the crest of a steep hill, the western approach to Warwick is most impressive, as the lower part of the West Gate is cut into the solid rock. The centre portion is the oldest and covered by a series of arches. The interesting and much-restored Chapel of St James stands over this. The tower was added at the west end around the year 1400. The remaining portion of the town's wall may still be seen from the north side of the gate.

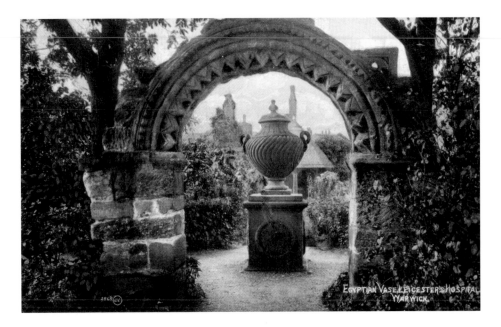

Egyptian Vase, Leicester's Hospital Warwick.

Egyptian Vase
Above: A lovely arched view of the famous Egyptian vase seen at the Lord Leycester Hospital garden. The arch is the decorative top of a Nilometer. This is a graduated pillar that shows the height to which the River Nile rises. It was brought back from Egypt by a former earl and presented to the hospital in 1880. The Norman arch came from the nearby West Gate.

The Warwick Vase
Below: Houses of note always appear to have famous vases and Warwick Castle is no exception. Here we see the Warwick vase, which can be found at Warwick Castle.

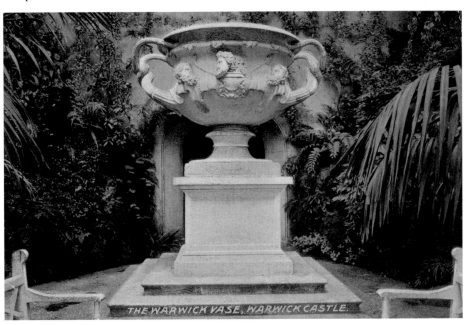

THE WARWICK VASE, WARWICK CASTLE.

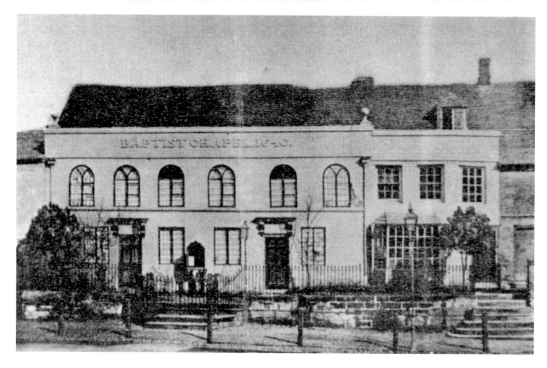

Baptist Chapel

Erected in or around 1744, to replace a former church which had been pulled down earlier, here is the old Baptist chapel. They say history repeats itself and this is certainly true to this day as a new Baptist church has recently been built on the site.

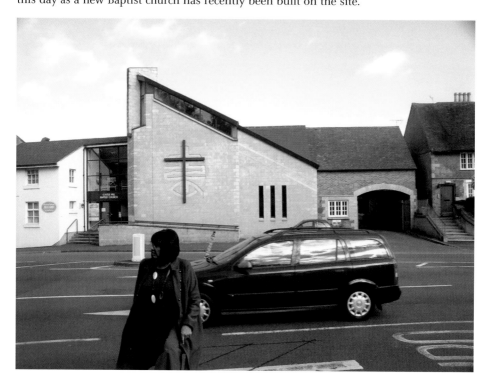

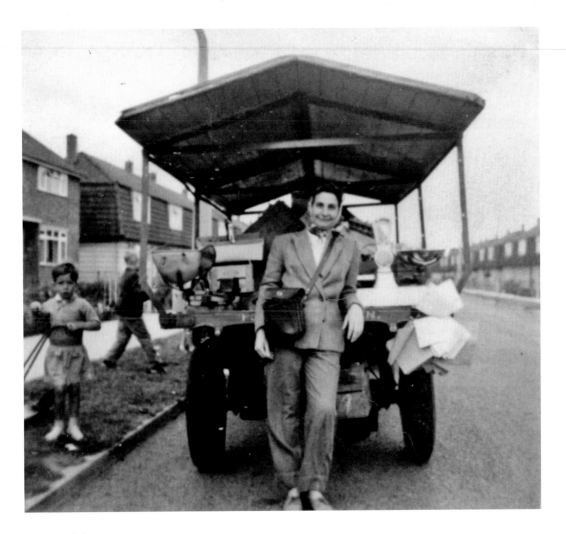

Mabel

One of the most memorable characters from my childhood has to be Mabel and her vegetable cart. Without fail, and duly assisted by her father Mr Buswell, Mabel would appear on the front door come rain or snow to deliver her vegetables. The cart was pulled by a horse, which was a character in his own right and partial to the odd flower in the front garden! Mabel was reliable and always cheerful and I can well recall one Christmas Eve when it was nearing midnight before she finally arrived. A lovely lady who has left many of her customers and the customers' children with happy memories of years gone by.

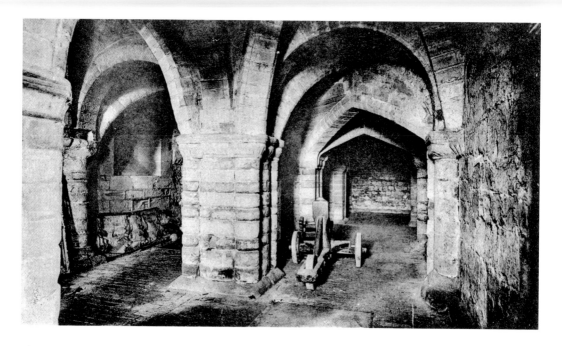

The Crypt
Above: Established as a collegiate church by Roger Newburgh, Earl of Warwick, in 1123, St Mary's crypt is the only original piece of architecture; its arches and cushion capitals carved in the simple method of the day remain. Preserved here is the ducking stool used in past centuries for criminal punishment. The crypt was later extended by Thomas Beauchamp, Earl of Warwick.

State Drawing Room
Below: I have included this photograph so that we could enjoy the inside of the castle as well as the outside, which is photographed more often. Here we see the State Drawing Room.

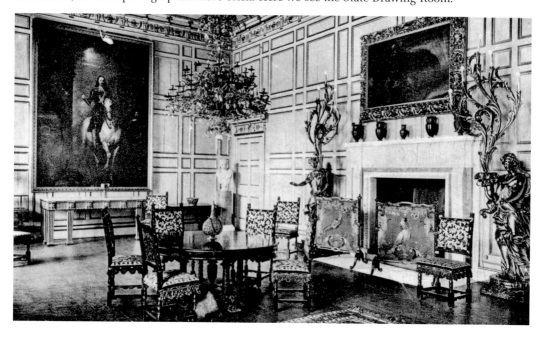

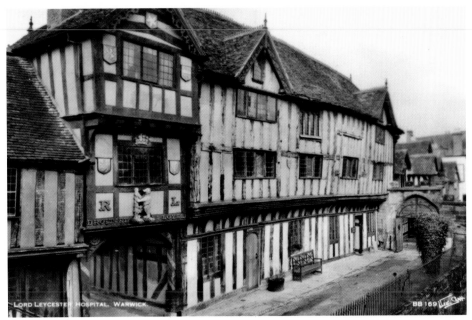

LORD LEYCESTER HOSPITAL. WARWICK BB 169

For the Pleasure of . . .
Two delightful views of the
Lord Leycester Hospital.

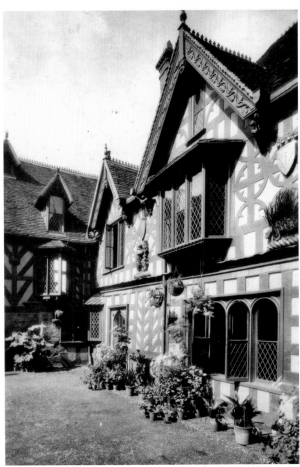

31

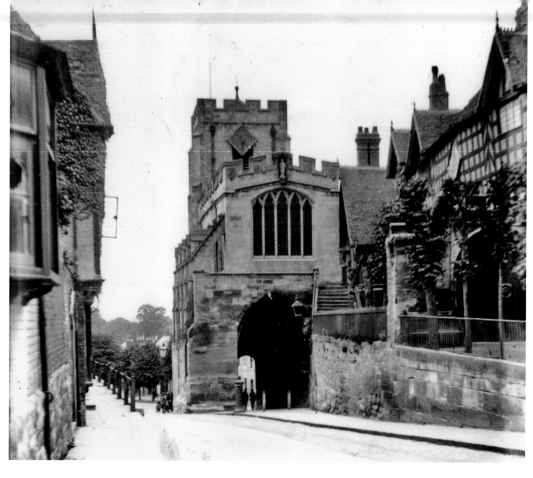

Chapel of St James
Warwick's West Gate with the fifteenth century chapel of St James built over it. Lord
Leycester Hospital is tucked in just beside it on the right.

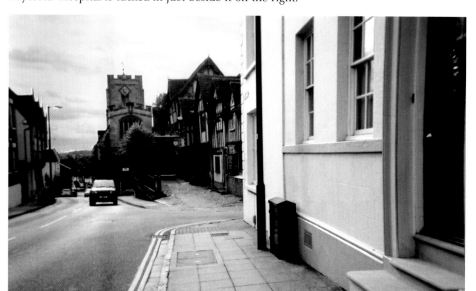

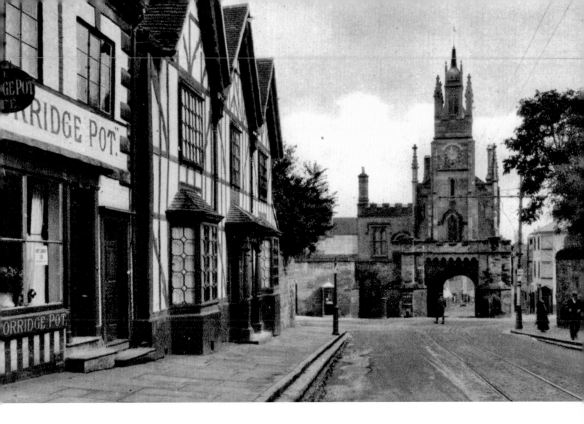

Jury Street

The previous owner of the Porridge Pot was J. Spicer, 'Bird and Animal Preserver'. It is claimed that the smell of boiling skins was noxious.

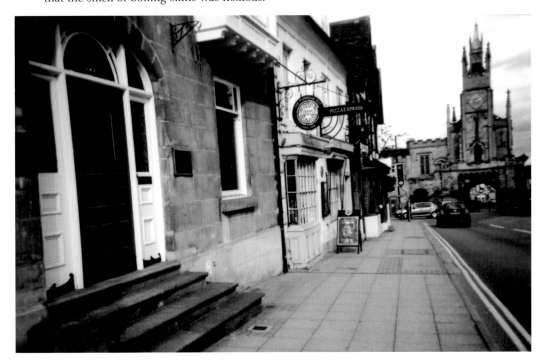

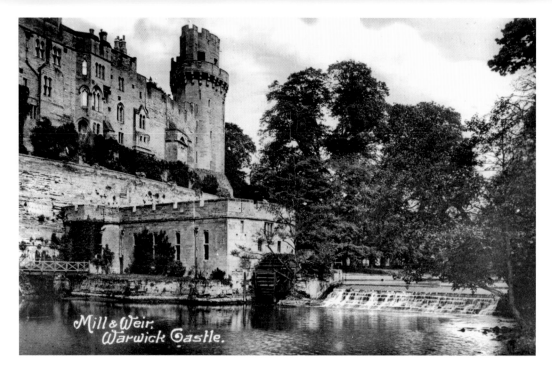

Mill & Weir,
Warwick Castle.

The Old Mill

The small building is the old pump mill, which was opened to the public in early 2002. The castle was one of the first great homes to benefit from a mill-produced source of electrical power.

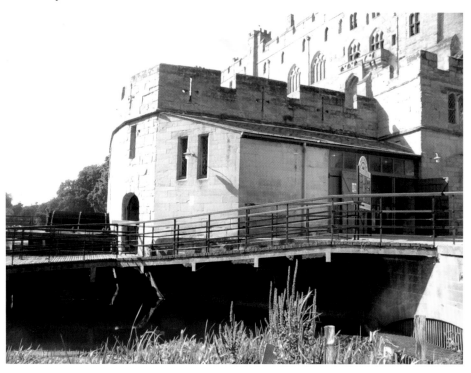

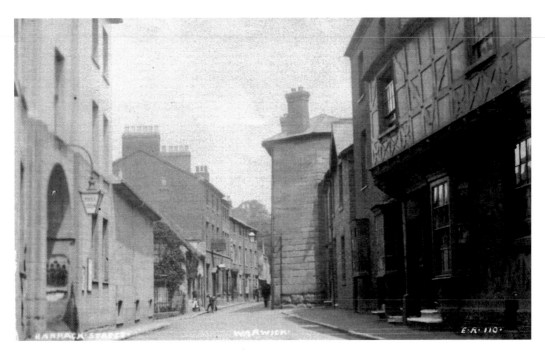

Barrack Street

On the left is the old police station and beyond is the Hare and Hounds Inn. On the right is the old jail. When the prisoners were moved to the new Cape Prison the building was used as barracks and army offices.

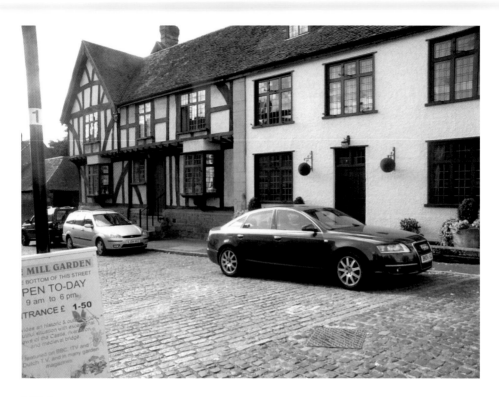

Mill Street

The great fire of Warwick in 1694 did not reach this area of town, which proved very lucky as Mill Street has many timber-framed houses on it. The houses seen here date from the sixteenth century. Further up the street is Allen's House and this would also have been built around 1600.

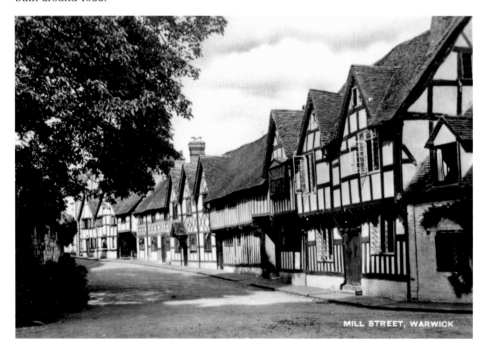

MILL STREET, WARWICK

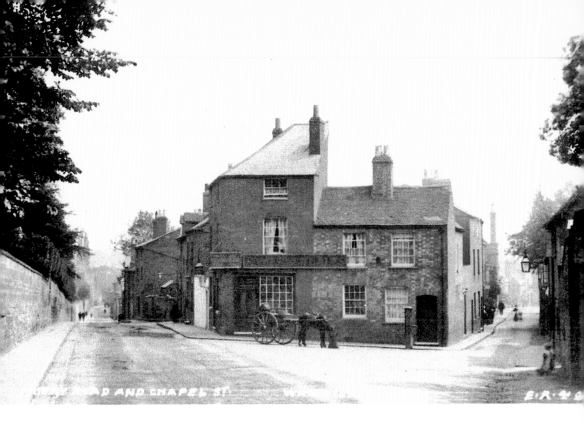

The Woodman

No longer a public house, the white building in the centre of the photograph that splits the Priory Road and Chapel Street was known as the Woodman public house when I was a child. Alas, it has fallen casualty to the drink laws and is no longer in business.

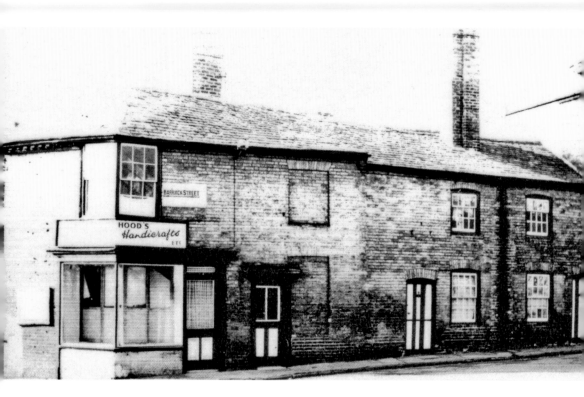

Hood's Handicraft

This lovely old shop stood on the right-hand side of the bridge next to the police station that was further along the road. On the opposite side of the bridge stood a private residence.

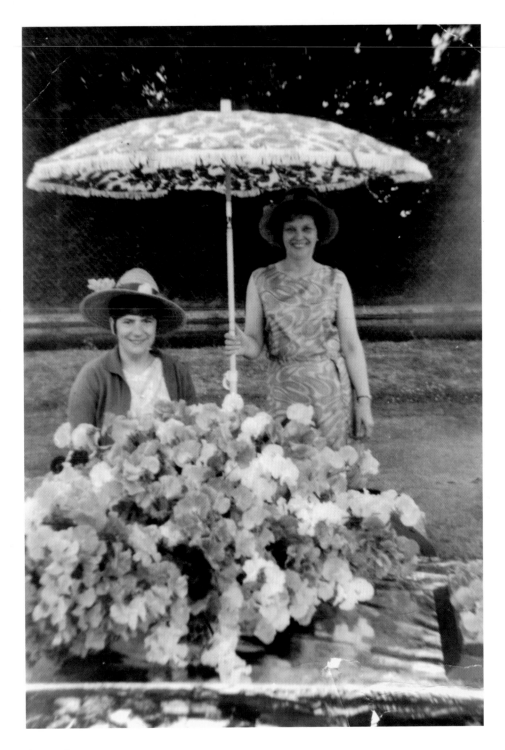

Sports Day
Taken in the early seventies, here we see Jackie Kord on the left and Pam Wills on the right selling sweet peas at a local sports day. Grown by Alan Williams, the sweet peas were not only colourful to the eye but also smelt beautiful.

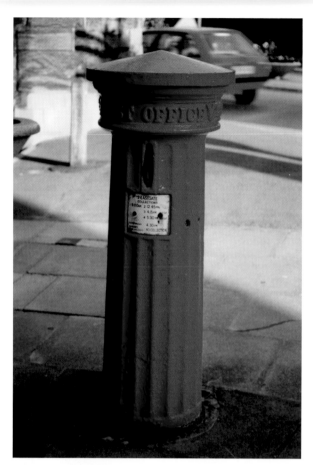

Red Pillar Box
Visitors to the town cannot fail to notice this lovely red pillar box at East Gate. A plaque nearby reads, 'This pillar-box, cast in 1856 in the shape of a Doric column at the Eagle Foundry of Messrs Smith and Hawkes, Broad Street, Birmingham, is one of a pair installed at the East and West Gates of Warwick.' The box featured on a set of stamps to commemorate postboxes of note.

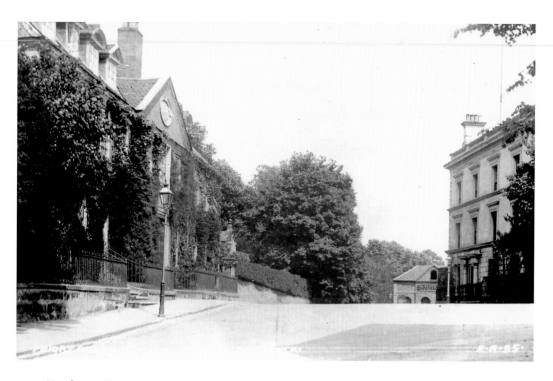

Northgate House

Northgate House stands near the site of the old North Gate of the town. The house was built at the end of the seventeenth century.

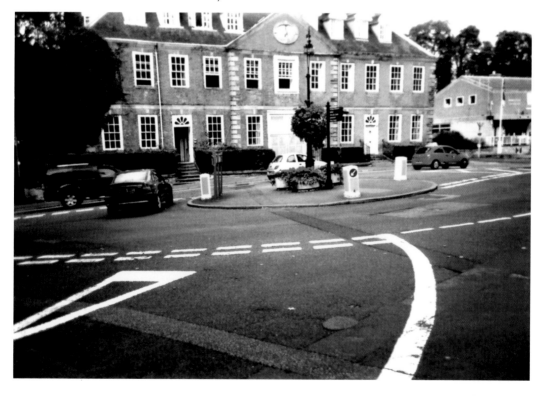

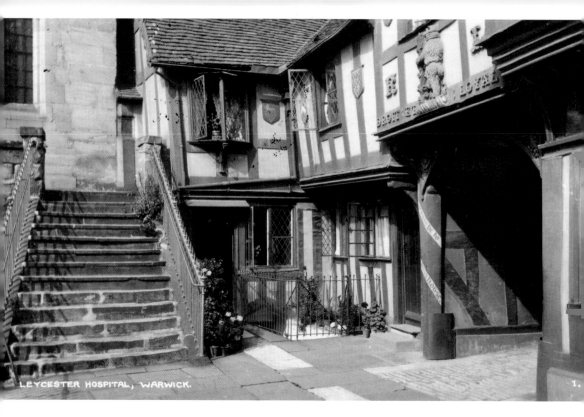

St James' Chapel

Taken in 1922, this picture shows the steps which lead up to St James' Chapel. The doorway on the right is the entrance to the Great Hall.

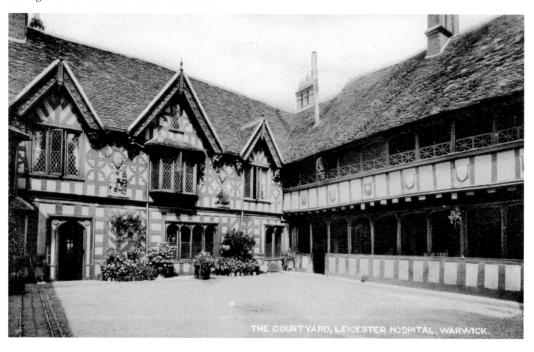

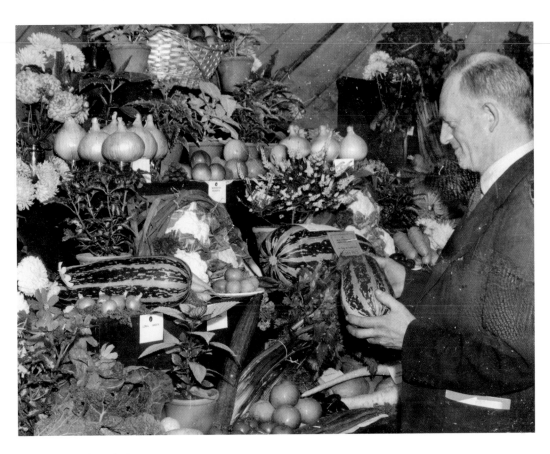

Horticultural Show

Here we see a fine example of the produce entered by Imperial Foundry at the annual Warwick Horticultural and Allotment Society show at St Nicholas Park in 1953. Mr A. W. Payne is seen here admiring the exhibits.

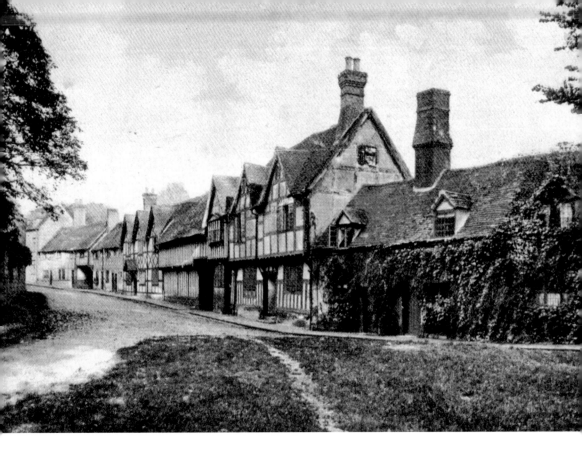

Mill Street
Two delightful views of Mill Street looking east.

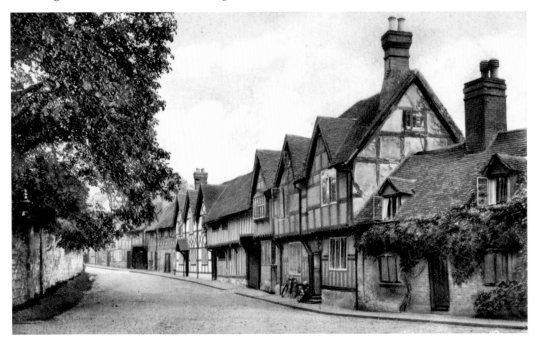

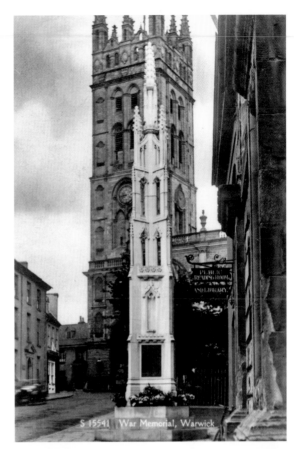

S 15541 War Memorial, Warwick

War Memorial
The site of the war memorial is significant, as it had been erected at the end of the railings where casualty notices were posted during the First World War.

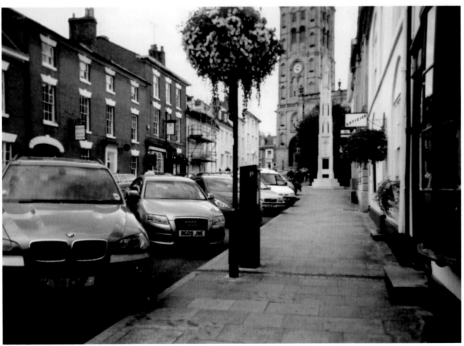

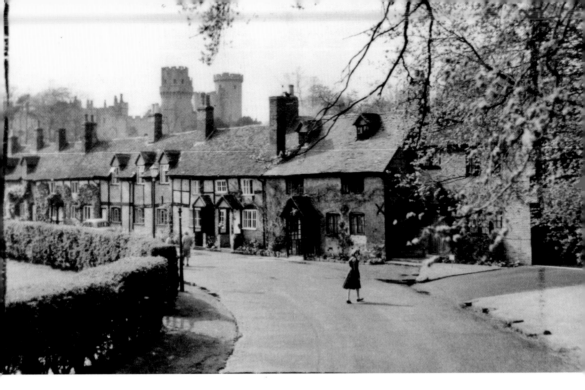

Bridge End

Bridge End is an area across the river from the castle, which appears romantically in the background of this photograph taken in the 1950s. Many of these old houses look very much the same as they always have done and have changed very little over the years.

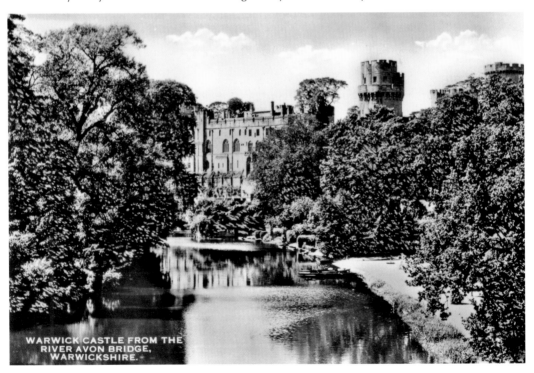

WARWICK CASTLE FROM THE
RIVER AVON BRIDGE,
WARWICKSHIRE.

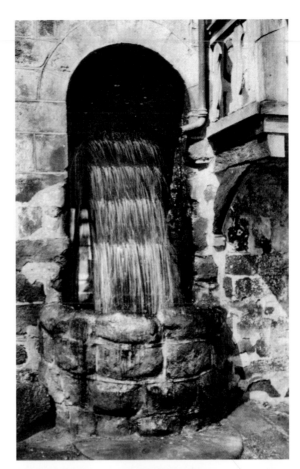

The Mill Wheel
Here we see two different photographs of the mill wheel. On the top is the original mill wheel and on the bottom is a photograph of how the mill wheel looks now, with a glass panel installed for viewing.

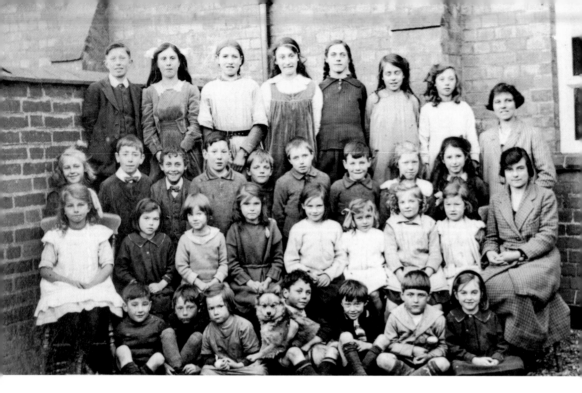

At School

Above: I love this old picture of a group of Warwick schoolgirls in the 1890s and have included it for your pleasure.

Westgate Primary

Below: Westgate School, built in 1884, had places for 850 children who were taught in three large rooms, a gallery and six classrooms. In 1892, the school log indicated that there were only 350 pupils. The school has recently celebrated 125 years of teaching.

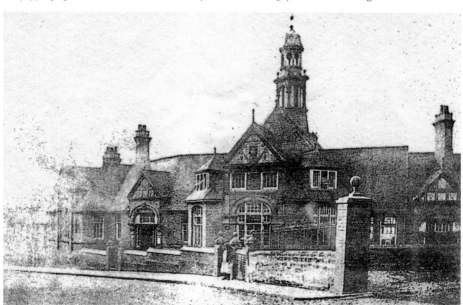

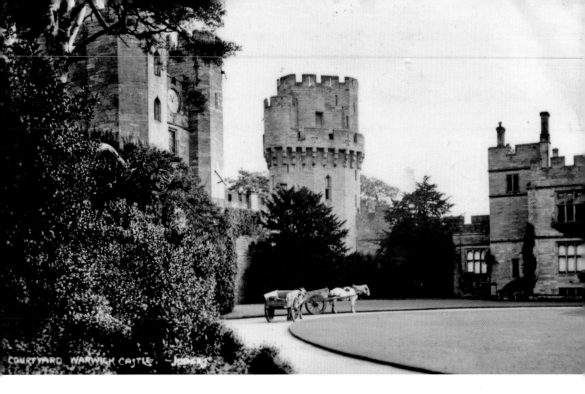

Warwick Castle

Warwick Castle towers high on a precipice of solid rock and affords the visitor one of the most picturesque views in England. Its massive walls reach down to the River Avon, which runs below it.

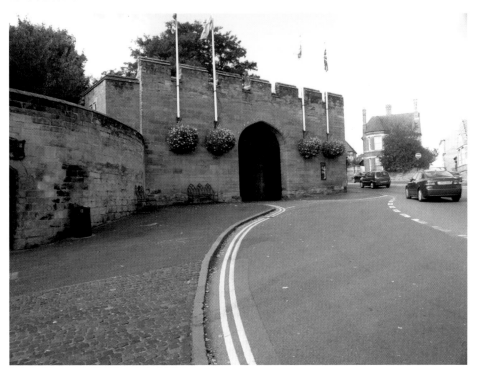

Guy's Cliffe Mill

I have included this photograph as it shows a very tranquil and picturesque back view of Guy's Cliffe Mill from the river around 1910.

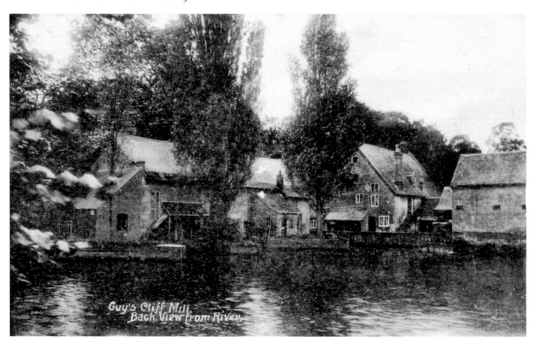

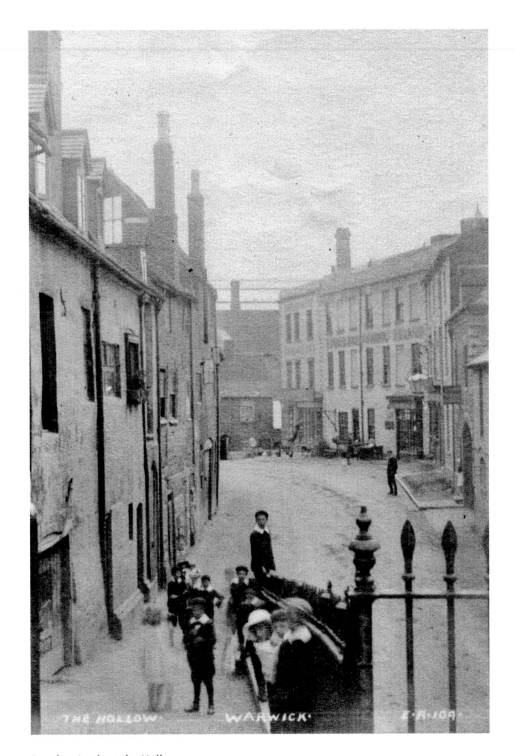

Another Look at the Holloway

The view is seen from the bridge and looks towards the market place around 1907. When the photograph was taken, the Holloway was a main thoroughfare into the town from the Saltisford.

Childrens' Party
Children seen enjoying the Imperial Foundry's childrens' Christmas party for employees in the 1960s.

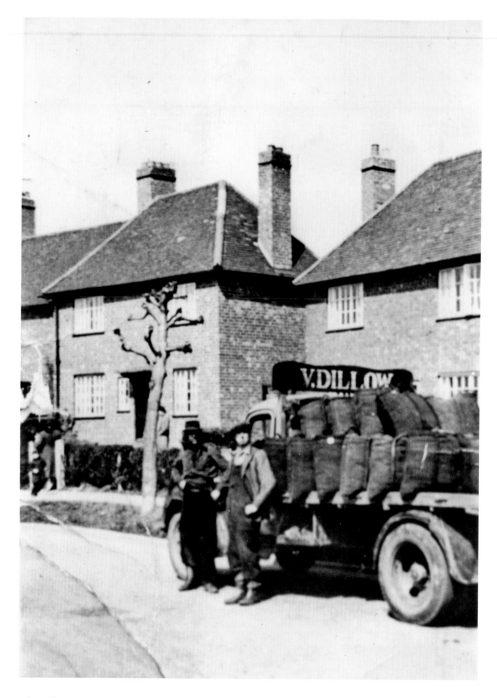

Vic Dillow the Coal Man

It was quite a common sight in the forties and fifties to see the coalman delivering his coal in black sacks from a dirty, dusty coal lorry. There were few houses with central heating at this time, and the open fire was the only means of heating the home. Vic Dillow was one of Warwick's famous coalmen who would carry the sacks of coal on their backs to coal bunkers. Here we see Vic and his associate delivering coal in Cape Road.

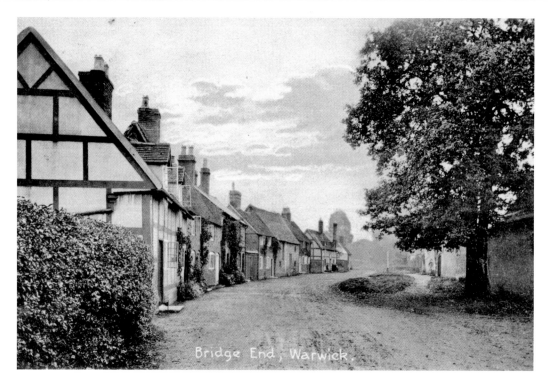

Bridge End

Bridge End lies at the end of the old bridge into Warwick and is now a much sought after area of the town. It is tranquil and still retains the charisma of old Warwick.

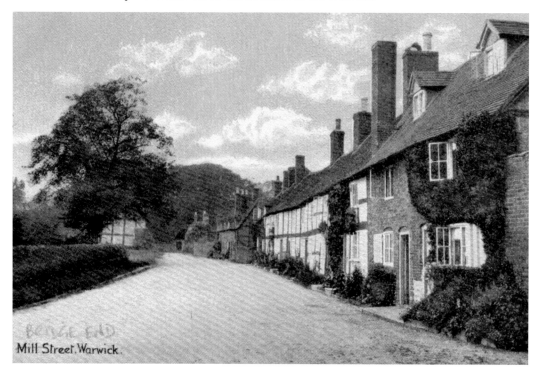

Mill Street. Warwick.

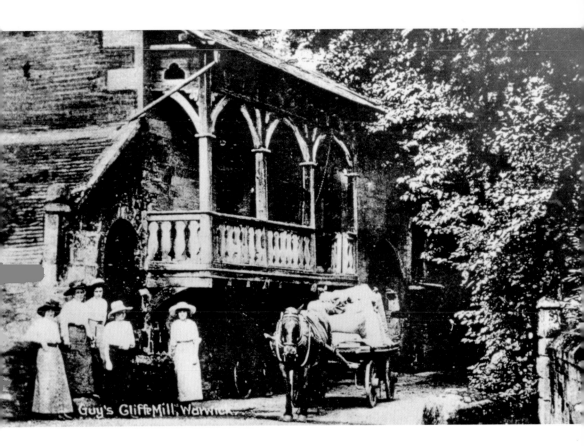

Guy's Cliffe Mill

Originally built in the twelfth century, the present building is chiefly eighteenth century and stands about a mile and a half north-east of the town of Warwick. After much alteration and renovation, the building is now a very popular bar and restaurant.

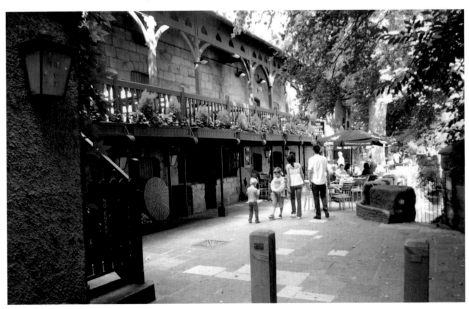

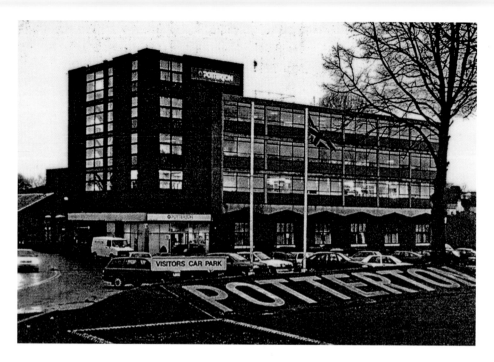

Thomas Potterton

Situated on the outskirts of Warwick and manufacturing, among other things, small bore gas-fired heating equipment, was Thomas Potterton's. On D-Day, 6 June 1944, Thomas Potterton joined the De La Rue Group. The company is no more on the Emscote site and a brand new medical centre and housing complex stands on the former site.

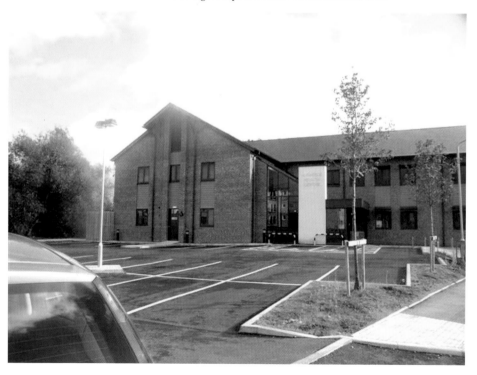

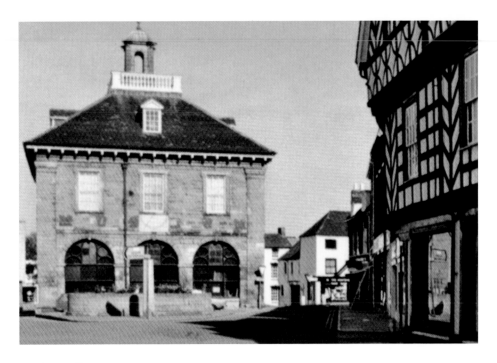

Market Hall

Erected in 1670 and constructed of stone, the building originally had open arches in the lower storey, three on the ends and five on the sides, which are now filled in with windows. I well remember, many years ago, the curator saying to me that the plan was to open the arches again but to date nothing of this nature has taken place. There are two fine rooms on the first floor and others in the roof. The market hall is now home to the County Museum.

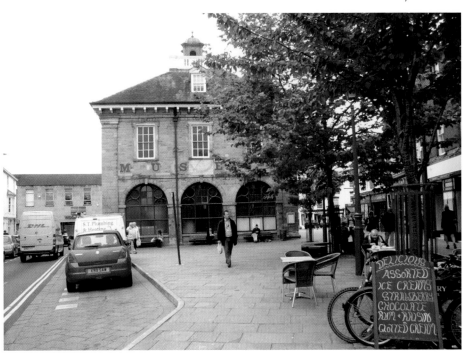

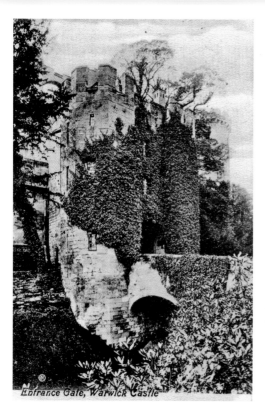

Entrance Gate, Warwick Castle

The Castle Entrance

This impressive photograph of the entrance to the castle shows the ivy, which no longer clings to the walls. To a visitor, the entrance gives a good example of the height of the castle. Used in various period films (*Prince Valiant* comes to mind), the castle lends itself beautifully to being used as the setting for such productions.

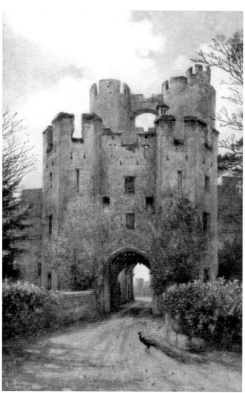

Jim Attwood and Barrie Eden
Here we see two different eras in bus driving through time. Jim Attwood, who for many years drove the local Midland Red bus at a time when the buses were just coming back into service after the Second World War, and Barrie Eden, who currently drives for Stagecoach. Stagecoach has now replaced Midland Red, and where Jim Attwood would have a clippie, Barrie Eden, seen here ready for departure in the G1, is both driver and conductor of the vehicle.

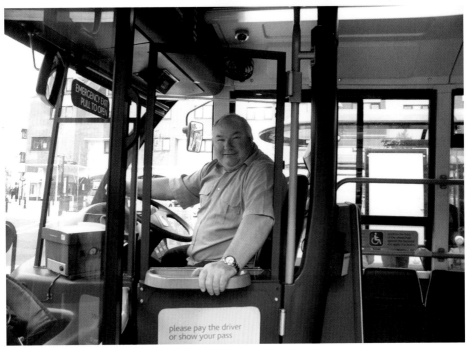

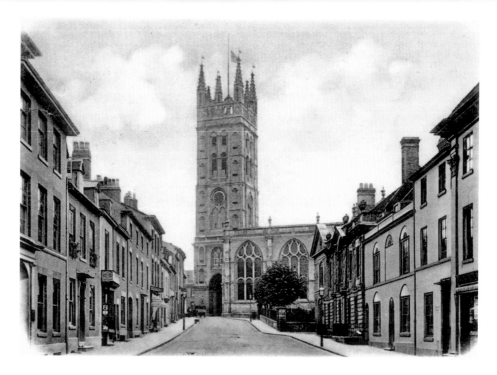

Church Street

St Mary's church dominates Church Street. On the left is the Zetland Arms Hotel. The building on the right of the war memorial was, for many years, the public library. Further down the same row of houses was Billy Raven's betting shop, which flourished in Church Street. During the Middle Ages, St Mary's amassed a collection of holy relics, which have since disappeared.

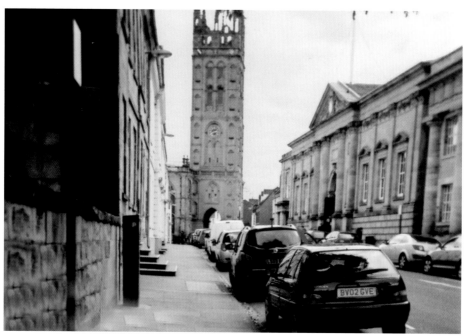

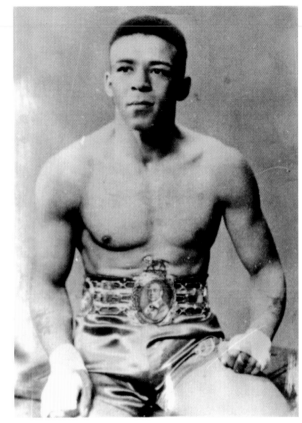

Randolph Turpin

No history of Warwick can really be complete without mention of Randolph Turpin, who became the first British world middleweight champion in sixty years when he beat Sugar Ray Robinson, the undisputed world champion, on 12 September 1951. Sadly, Randolph Turpin became the victim of a shooting accident and died in 1966. In honour of the town's famous son, a statue, erected in memory of his great achievement in the world of boxing, stands in the market place and is visited by people from all over the world.

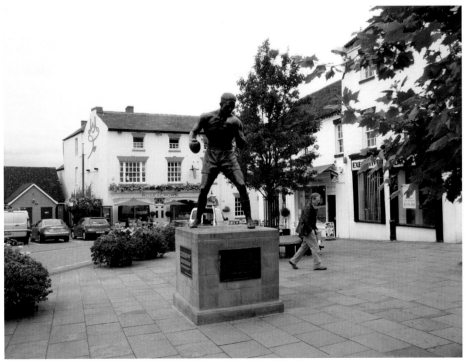

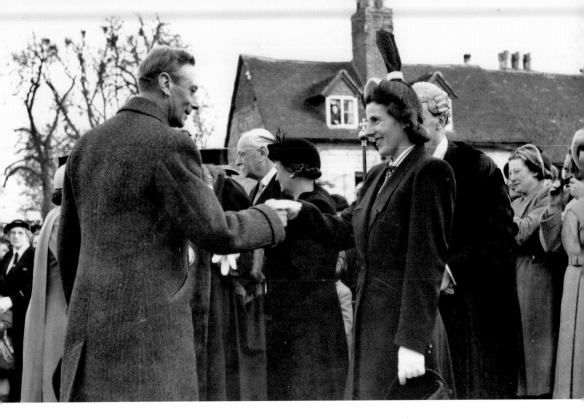

King George VI
King George VI, seen here shaking hands with Mrs O. Sheppard, wife of the town clerk, on a walk about in Warwick on 5 April 1951, only ten months before his death. He was on a visit with Queen Elizabeth.

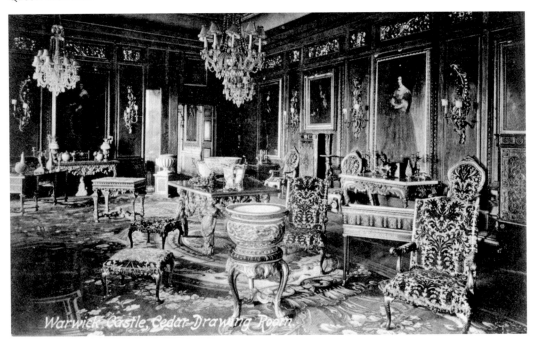

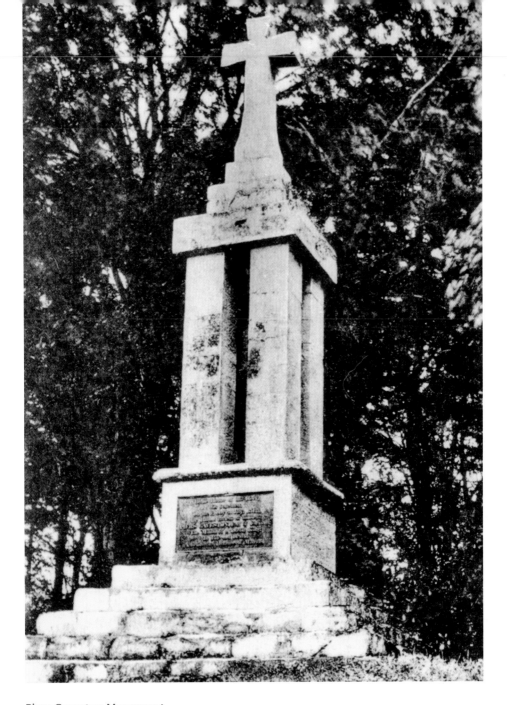

Piers Gaveston Monument

No account of Warwick would be complete without mention of Piers Gaveston, whose monument can be found at Leek Wootton on Blacklow Hill, just a mile or so from Warwick. Piers Gaveston was made Earl of Cornwall in 1307. Unfortunately, he was greedy as well as a proud man, who was to make more enemies in his lifetime than was good for him. He was captured by the Earl of Warwick, tried at Warwick Castle and sentenced to death. The monument marks the place where Gaveston was beheaded on 19 June 1312. His body was finally put to rest in Kings Langley, Hertfordshire, on 2 January 1315.

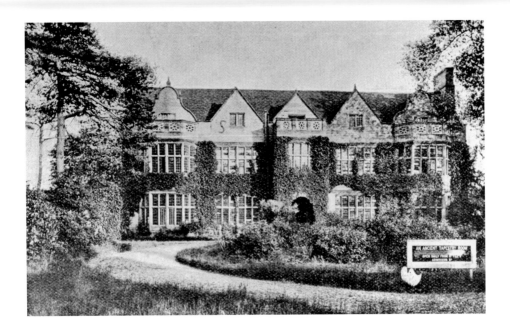

St John's House

Originally the Hospital of St John the Baptist, St John's House was founded in the reign of Henry II. Intended for the use of the homeless, poor and travelling strangers, the building consisted of a gatehouse, chapel and two houses but was to change its use several times before being purchased by the Earl of Warwick in 1780, where it remained in the family until 1960. Between 1791 and 1881, it was a school and in 1924 it became a Military Record and Pay Office. It is currently a branch of the Warwick County Museum and houses memorabilia of the Warwickshire Regiment.

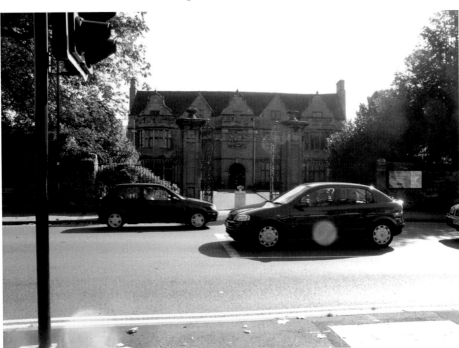

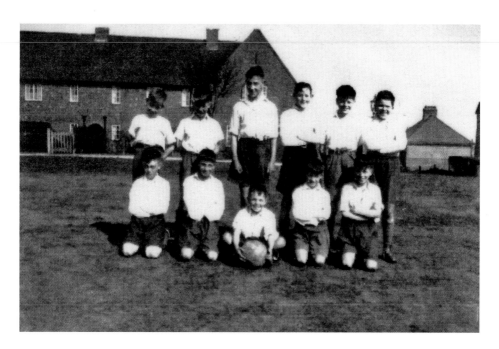

The Green

Taken in 1947, this photograph shows the Green Eleven football team taken on the Green in Warwick. Back row, left to right: unknown, Dick Philpot, Gordon Brind, Jim Briscoe, Mike Giles, Tony Marsh. Front row, left to right: Ray Farr, unknown, Bobby Wells, unknown, Michael Thornton. Although the children have all grown up, the Green remains much the same as it always has done.

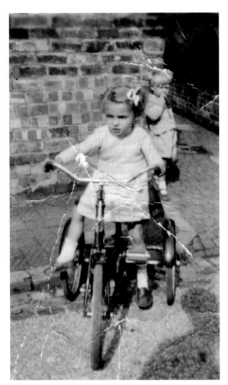
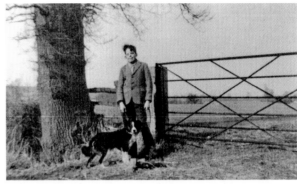
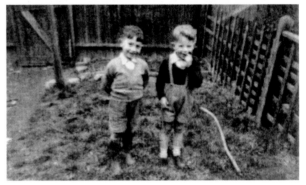

As We Were

This group of children are all grown up now, but it is nice to look back.

Above, clockwise from left: June Haynes, taken in 1949; Roland Cox with the dog up the Old Park Lane in Warwick; Robert Buswell and Roland Cox, taken around 1953.

Below: Terry Ivens taking a bath in the back garden in the late forties.

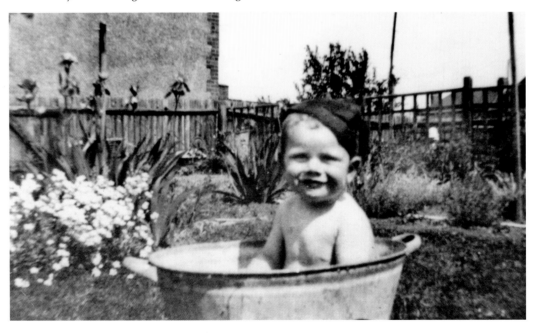

King Edward's School
The school that stands on the Myton Road was completed in 1879 to replace former premises, which lay west of the Butts. The Leamington architect J. Cundall designed the building.

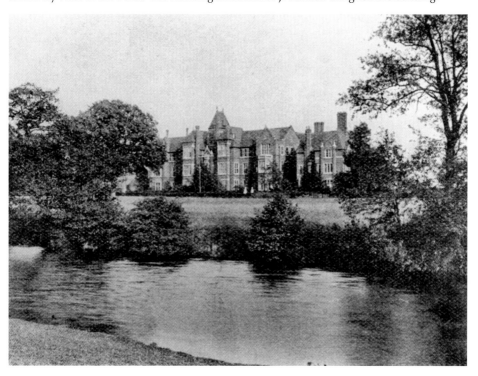

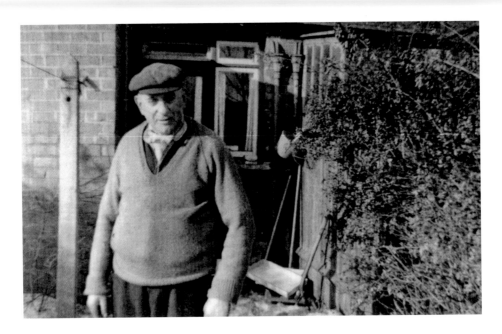

Allotments

Above: After the Second World War allotments became very popular and here we see Jack Cox in his back garden in Hanworth Road, The Cape, Warwick in 1950, dressed ready to go and work on his own allotment up Old Park lane.

Party Mood

Below: Here we see May Green in party mood, helping prepare a birthday party for Mr Tom Cox's eightieth birthday, in Pickard Street, Warwick. The birthday cake was delicious!

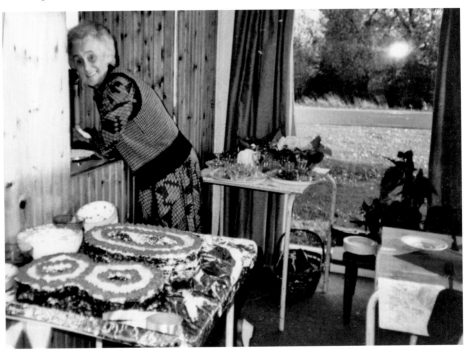

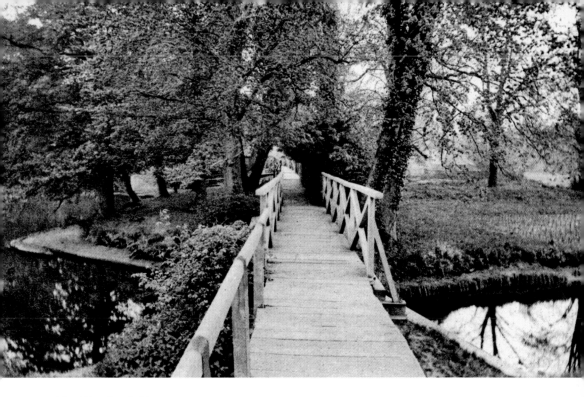

The Wooden Bridge

I have included this photograph as it will bring happy memories not only to the local brides, who would walk across the field after their marriage at the Milverton church for their reception at the Saxon Mill, but also for the many walkers who have crossed the bridge over the years. The day I took the photographs was no exception; the dog walkers were still there and here we see Frank Barriscale and his companion.

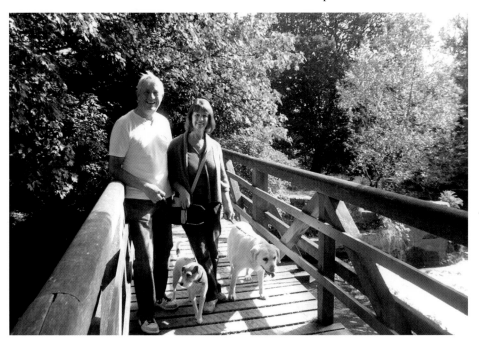

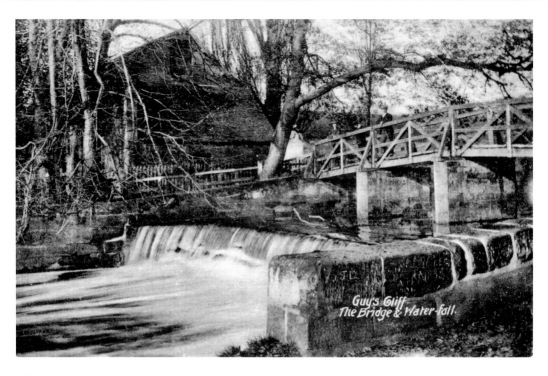

Guy's Cliff
The Bridge & Water-fall.

Old Wooden Bridge

As children we used to love to run across this old wooden bridge, which leads to the Saxon Mill across the River Avon, and pause to look for fish below us.

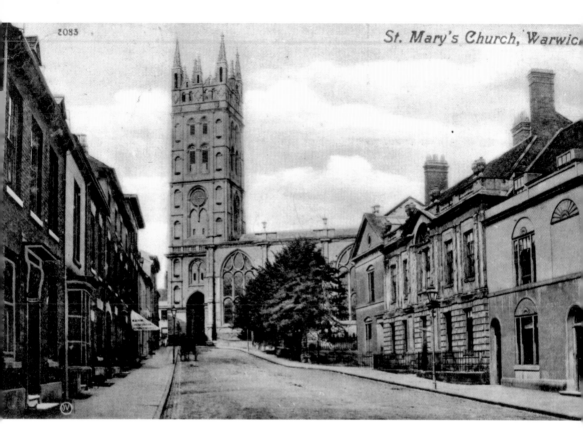

St. Mary's Church, Warwick

Sisters-in-law
Sisters-in-law Eleanor
Cox on the left and Molly
Cox on the right seen
walking into a church for
a service.

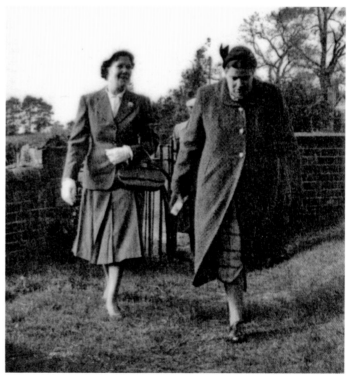

Ford Island

I have included this photograph as it shows what has become a very busy island in its early days. The junction of Princess Drive, Myton Road and Europa Way and the gateway to the local shopping park — this island is one best avoided if you can.

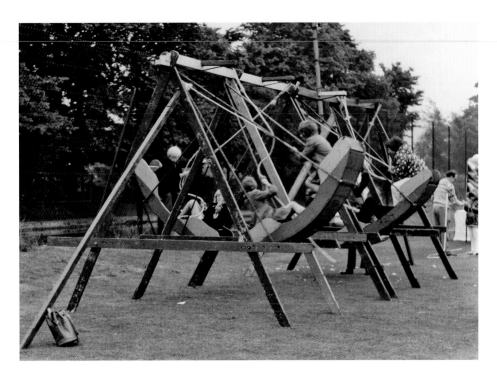

Happy Days

Above: No book would be complete without a picture of the children enjoying themselves in the sixties. The occasion was the Ford Motor Company Sports Day. Although the Ford foundry was on the Leamington side of the Grand Union Canal, the sports ground was on the Warwick side.

Sack Race

Below: Here we see the winner of the 1950 Ford Works Fête children's sack race.

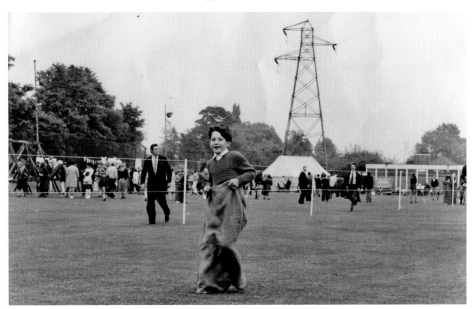

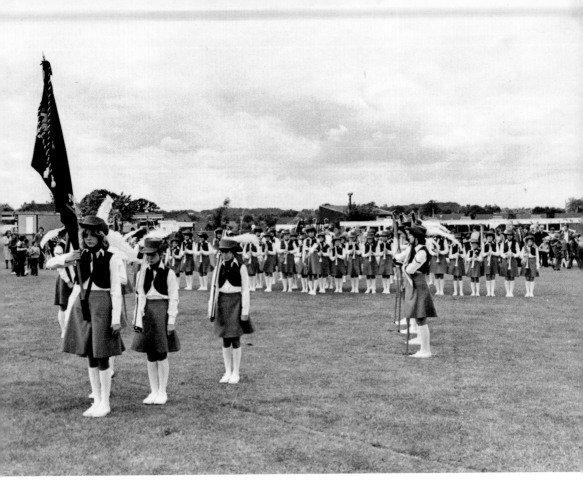

The Marching Band

The Warwick Corp of Drums has entertained the town for many years. The co-founder was Pat Walters, whose lovely daughter played in the band in its early days. The headquarters are off the Hampton Road and the group is now called The Warwick Girls Marching Band.

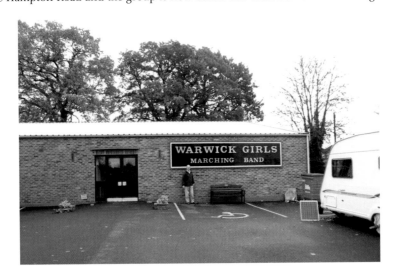

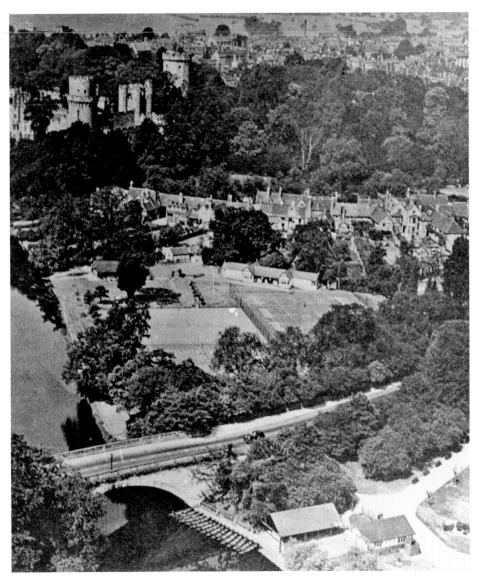

An Aerial View
Warwick Castle as seen from the air. The new bridge into Warwick and the tennis courts that skirt the River Avon are clearly visible. The houses are in Mill Street, which leads down to the castle.

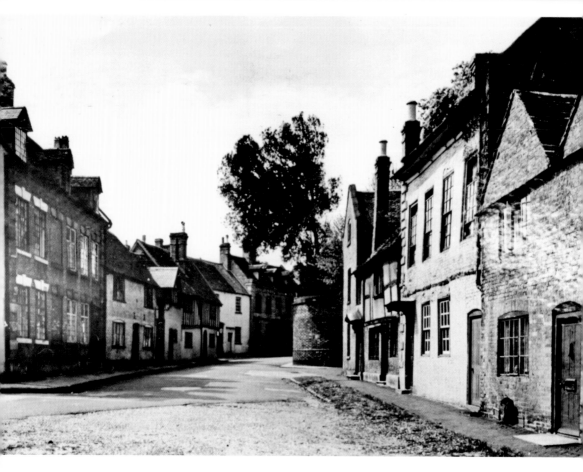

Castle Lane

Castle Lane skirts around the edge of Warwick Castle grounds. This old photograph looks onto Castle Lane, and as children we would walk down here to see the peacocks, who would often take a stroll around the town after flying over the castle wall.

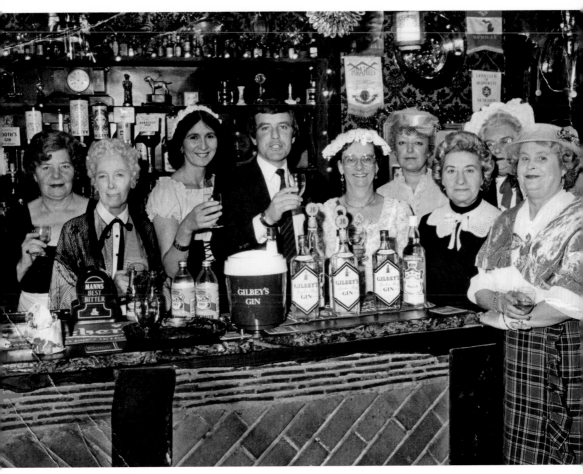

Victorian Evening
This lovely photograph was taken
behind the bar at the Roebuck Inn
on the town's Victorian Evening.
Held in December each year, the
event attracts visitors from all
around the area, who dress up
in old Victorian clothes to enjoy
the evening's atmosphere, which
includes stalls, choirs and, of course,
Father Christmas. The lady third
from the left is Jean Tichelly.

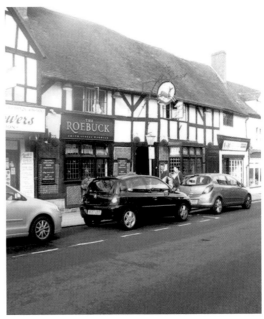

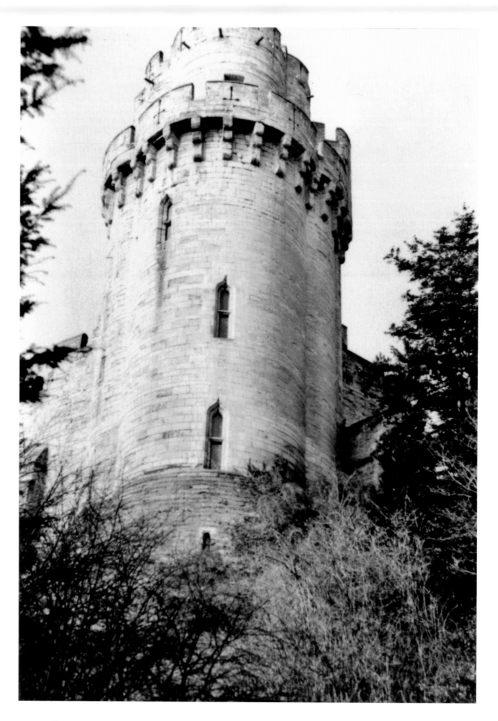

Caesar's Tower
Caeser's Tower was built in the fourteenth century to bring more security and luxury to Warwick Castle. Caeser's Tower and Guy's Tower were constructed to contain several storeys of bright rooms with fireplaces, garderobes and bedrooms. Built as part of the castle's defences, it is self-contained, and has floors devoted to dungeons, ammunition and family quarters.

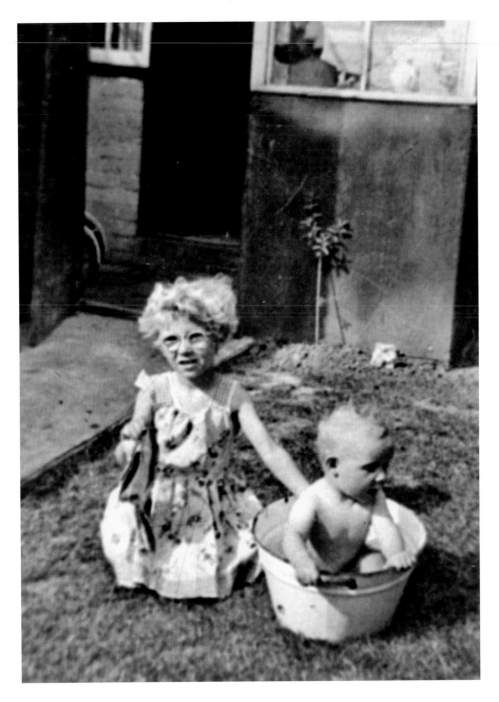

Sisters
Elizabeth and Lorraine Haynes playing in the garden at Newburgh Crescent in the late 1940s.

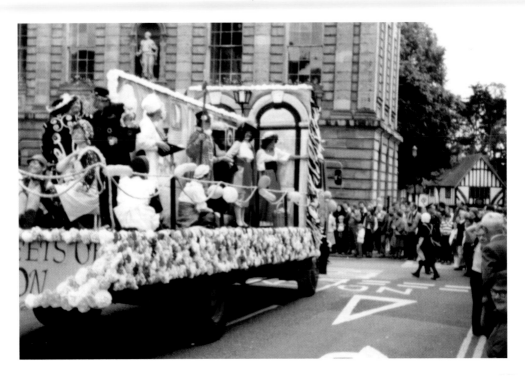

Warwick Carnival

Every year Warwick holds a carnival and here we see the town enjoying itself as the procession weaves its way down Church Street.

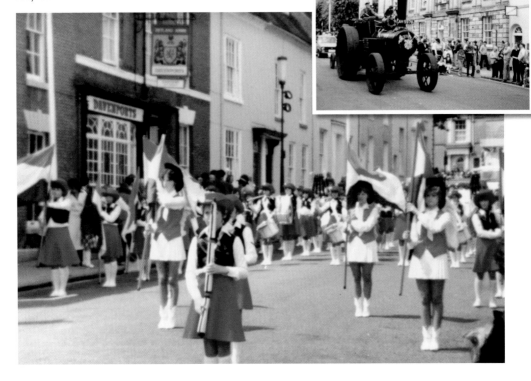

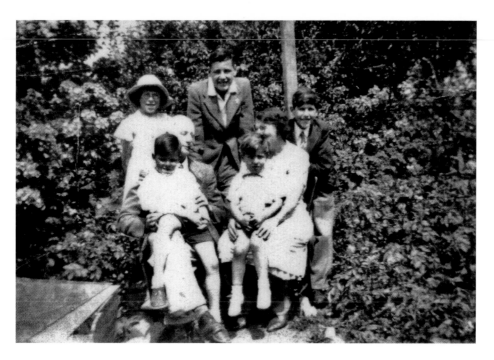

The Family

I always love to include a family in my books and this book is no exception. Here we see the Thornton family, who posed for this group picture in their back garden on the Green. Back row, left to right: Pamela Thornton, John Thornton. Front row, left to right: Douglas Thornton, Ken Thornton, Jack Thornton (father), Michael Thornton and Ethel Thornton (mother).

Warwick's Little Shop
Reminiscent of the little shops of my childhood is the one that conducted business at 36 Coventry Road. At one time it was run by Mrs Plant, who sold sweets, cigarettes and other familiar items found in small shops, such as a bag of sugar, a loaf of bread and a bottle of milk. Alas, the shop is no more and has been converted into a private residence.

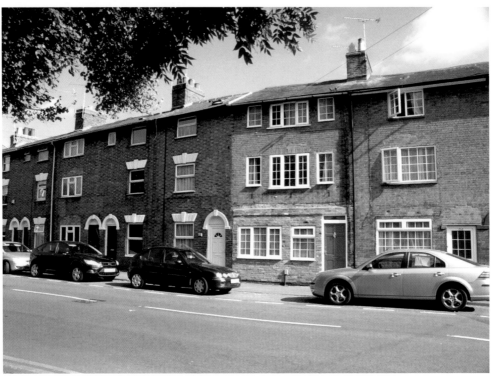

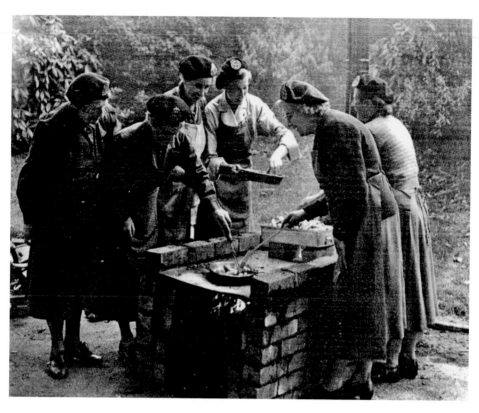

The Way We Were

Local volunteers of the Civil Defence Corps demonstrate emergency feeding techniques on their own brick hot plate in the Pageant Garden of Warwick in 1955.

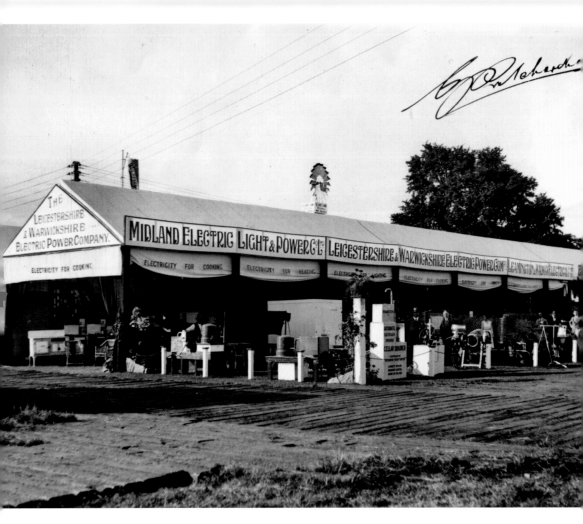

Midland Electric
Warwickshire is renowned for its exhibitions and here we see an example of the Midland Electric Light and Power exhibition held in the fifties.

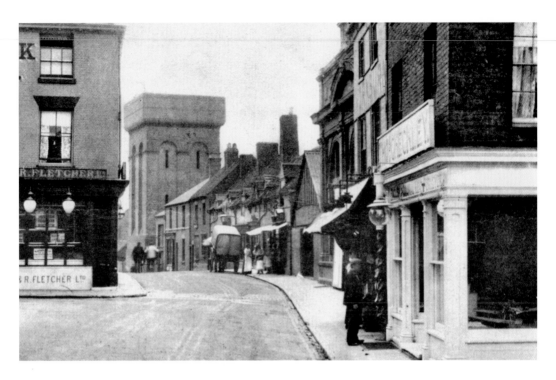

Water Tower

This picture shows the water tower taken in 1910. The tower was demolished in 1923. Fletcher's Stores is on the left of the picture and on the right and set back slightly behind the shop window is the Corn Exchange. Fletcher's is no more and an up-market clothing business has recently opened here.

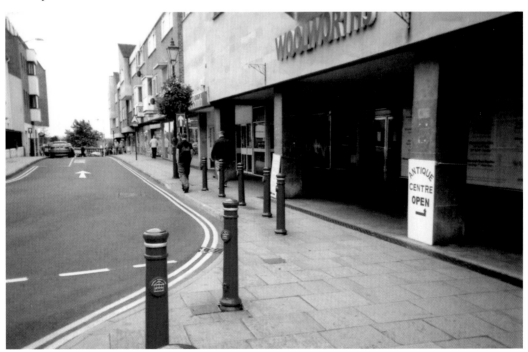

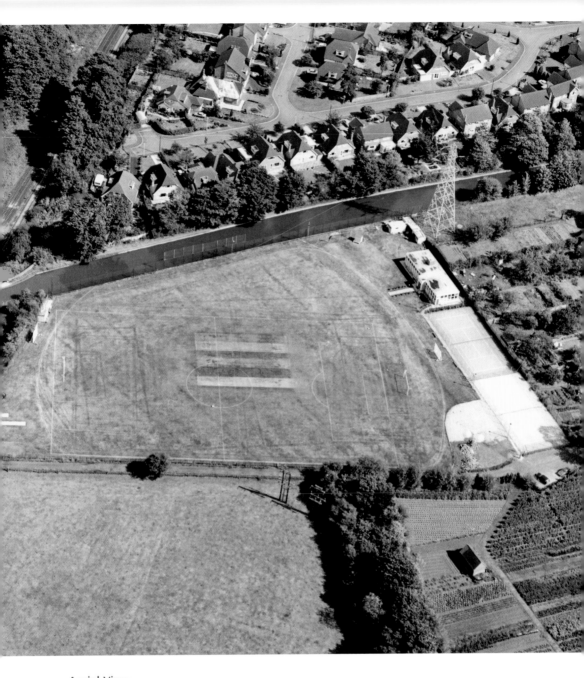

Aerial View

There is nothing like an aerial photograph and this one shows the old football pitch that has now become the site of the new Lidl store, which is part of the German supermarket chain.

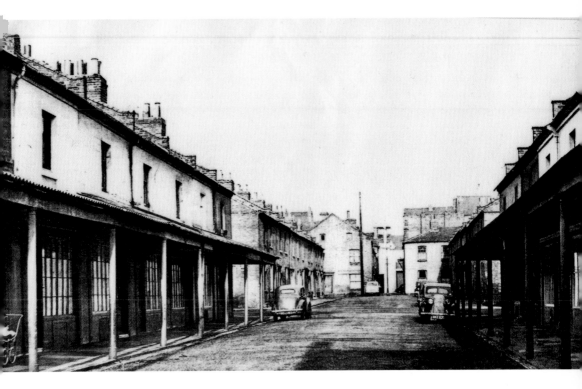

Covent Garden Market

Here we see the lovely old Covent Garden Market, which was demolished about 1960. The white building in the centre and the ground in front of it was to become the premises of Cartridge World. The site is now a council car park, although Cartridge World is still in business, I am pleased to say; in the world of writing these days it is a godsend — everything is on computers.

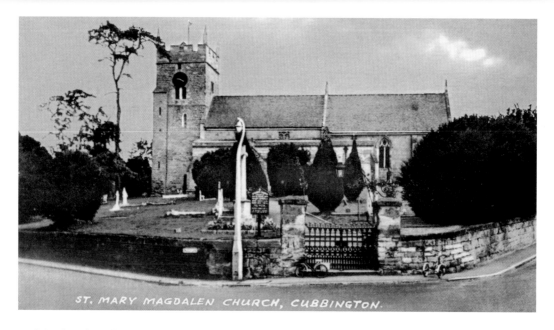

ST. MARY MAGDALEN CHURCH, CUBBINGTON.

Parish Church, Cubbington

The parish church of Cubbington is dedicated to the 'Nativity of our Lady'. The church consisted of a nave, south aisle and a small chancel, with the tower being added about 1857. As you enter the church, you are struck by the curious appearance of the walls. It is almost as if they have departed from the perpendicular.

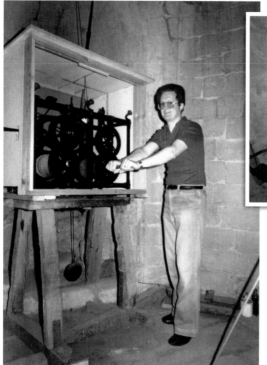

Cubbington Clock
Andrew Wild is seen here winding the Cubbington church clock, a duty he performed for many years. As a Cubbington lad he took great pride not only in the clock but the workings as well, which were an historic item in their own right.

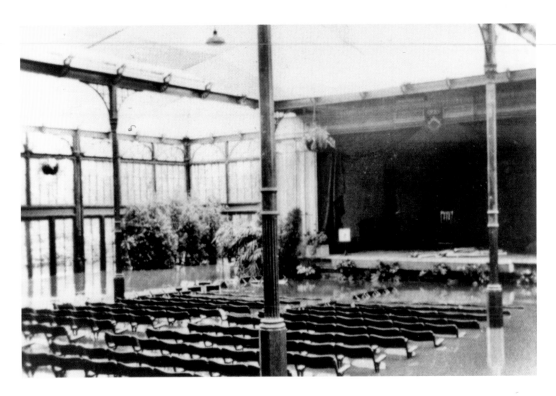

Jephson Gardens Pavilion

Dr Hitchman donated money towards the formal layout of the Jephson Gardens. He died in 1867. The proviso with the donation was that the work be carried out by the unemployed in the area. By the River Leam side of the gardens they built a pavilion and here is a delightful photograph of the auditorium. Sadly, we do not have a pavilion in the Jephson Gardens now. There was something just magical about walking through the gardens to listen to a concert on a Sunday evening.

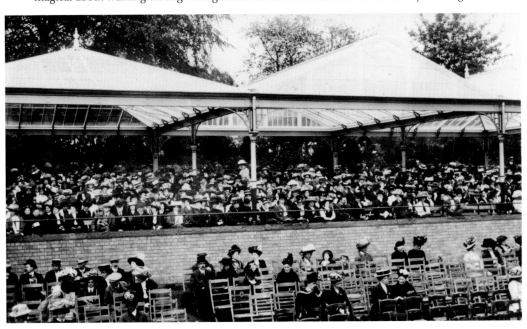

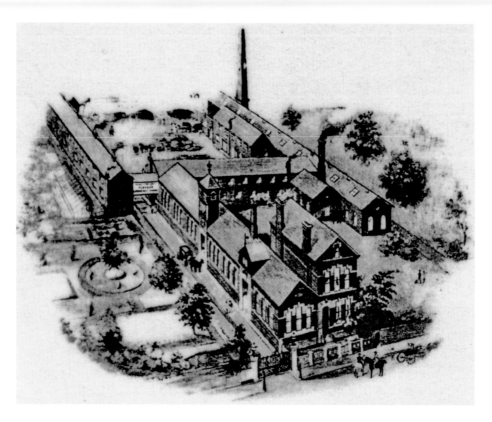

The Eagle Foundry

The Eagle Foundry, drawn in 1867, shows the Sidney Flavel and Company Limited site adjacent to the Ranelagh Gardens (front left). The gardens lost their popularity during the opening of the Jephson Gardens and were eventually to become part of a Flavel's expansion programme.

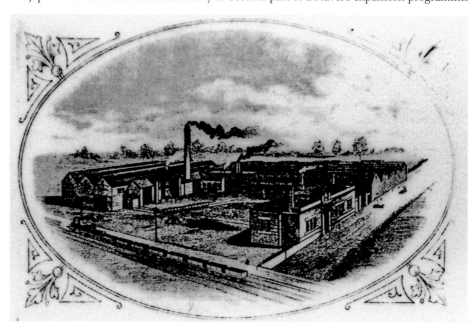

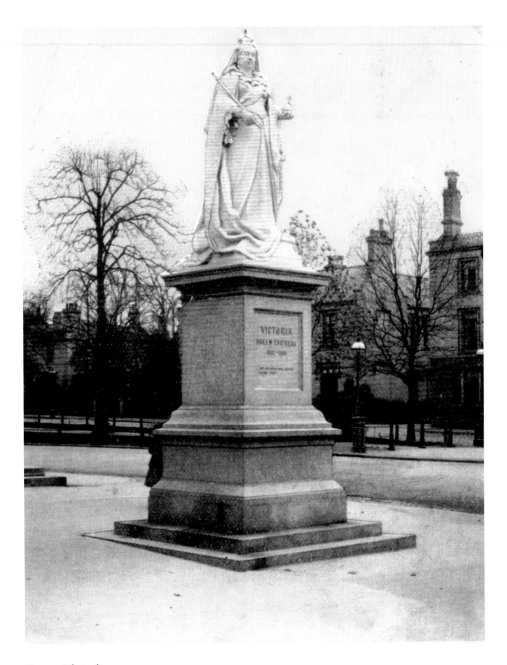

Queen Victoria

Queen Victoria visited Royal Leamington Spa both as princess and as the queen. During the night of 14 November 1940, a nearby bomb blast moved her statue on its plinth by about an inch. This was the night of the Coventry blitz and our more senior readers may well remember this event clearly. To date, the statue has never been put back.

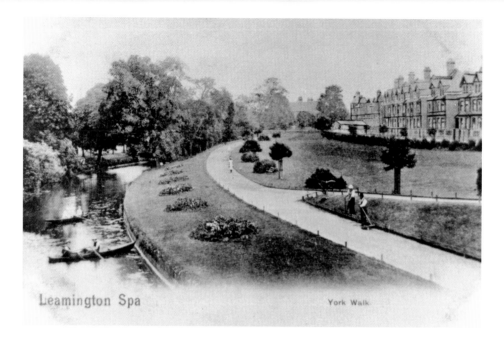

Leamington Spa York Walk

York Walk

Although the houses still look the same, the present day York Walk bears no resemblance to the one we see in the photograph. Trees have been planted and have grown very tall and the lovely flowerbeds are no more. Neither are there boats on this stretch of the River Leam. The only boats one sees now belong to the local canoe club.

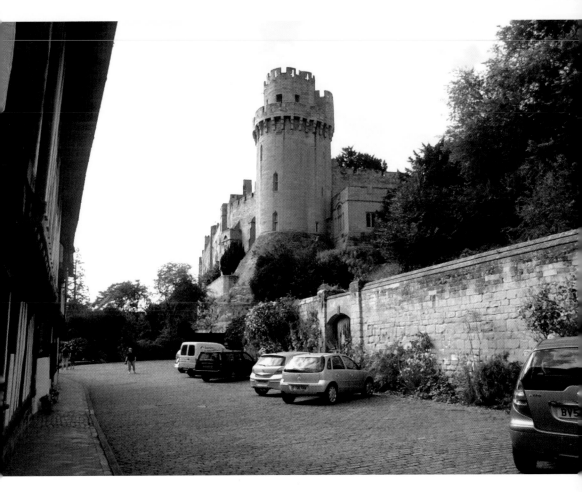

Caesar's Tower

The splendid Caesar's Tower at Warwick Castle was built during the fourteenth century and at the time of the de Beauchamp earls. None of the present castle buildings date from before the thirteenth century, but there is clear evidence of the earlier motte-and-bailey construction that preceded the one we see today.

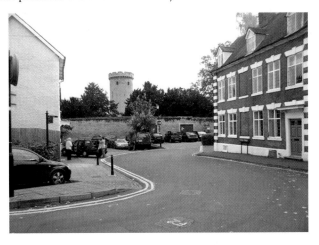

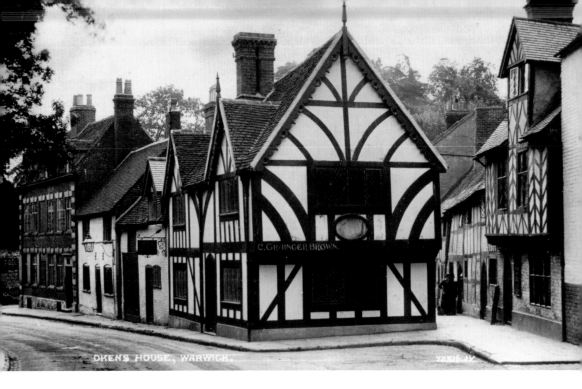

Oken's House

This house dates back to the sixteenth century, and from 1885 until 1909 W. Clarke, a baker, was on the premises. Much later it was taken over by Grainger Brown Antiques and became a successful dolls' museum. Currently, it is being run as tea shop.

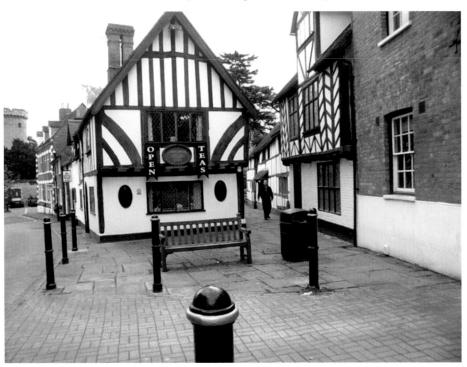

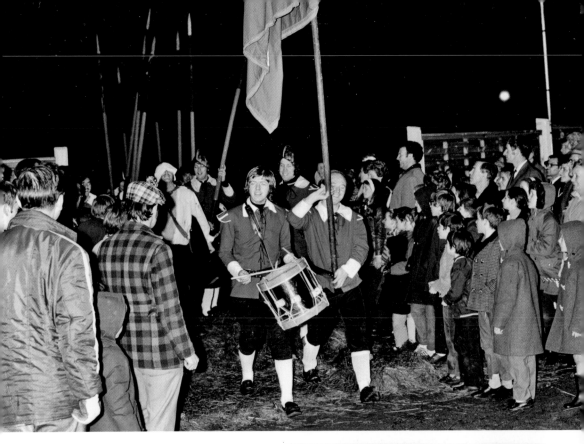

Bonfire Night

Above: Here we see the grand entry of the Sealed Knot who were performing the opening ceremony and lighting the bonfire for the Ford Motor Company Limited firework display in the early 1960s. The man on the right of the drum player is Steve Whitby.

Cubbington

Below: Two delightful postcards of old Cubbington, a village which lies on the outskirts of Royal Leamington Spa.

OLD WORLD COTTAGE, CHURCH LANE, CUBBINGTON

VIEW FROM CHURCH, CUBBINGTON

Afterword

I had no idea when I set out to take the photographs for this book that I would be seeing parts of Warwick I never knew existed. The beautiful, tranquil garden at St John's House and the equally pleasant grounds of the pageant house, the lovely, old fish-pond behind the county court and that jewel in the crown, Arthur Measures private garden, 'the Mill Garden', which stands at the bottom of Mill Street. For hundreds of years, traffic would have travelled down here to the old bridge and the castle corn mill. The old road came directly from the centre of the town through the present castle wall opposite the Mill Garden and over the bridge, the ruins of which can be seen clearly from the gardens. The bridge was eleven spans in length and very narrow. In all probability, it would have taken no more than pedestrians, livestock and packhorses.

The castle mill, which you can see from the gardens, is a corn mill that was built of wood under the castle wall, and a cloth mill was built the other side of the bridge in Bridge End. The corn mill was later replaced by an imposing stone building visible from the Mill Garden. It ground corn well into the late 1800s. It was subsequently turned into a generating mill providing electricity for the castle, its timber yard and some of the cottages in Mill Street and Bridge End. Although the water-wheel still goes round, the use of the mill ended in about 1945.

During the great fire, Mill Street was not affected and some of the old houses date well back in history. The original Mill Garden Cottage, for example, was built of sandstone around 1398, to house the bridge keeper. This house would have been built during the reign of Richard II, just twenty-two years after the death of the Black Prince.

All of Warwick is steeped in history, and thanks to careful planning over the years, much of the history still survives to this day.

As a person born and bred in Warwick, it has been a pleasure to compile *Warwick Through Time* for you, and I hope that you derive as much pleasure from reading its contents as I did from writing them.

The cottages at the front of this old postcard are a rear view of the houses which stand in Mill Street. Behind the houses Warwick Castle can be seen.